wedding photography
now!

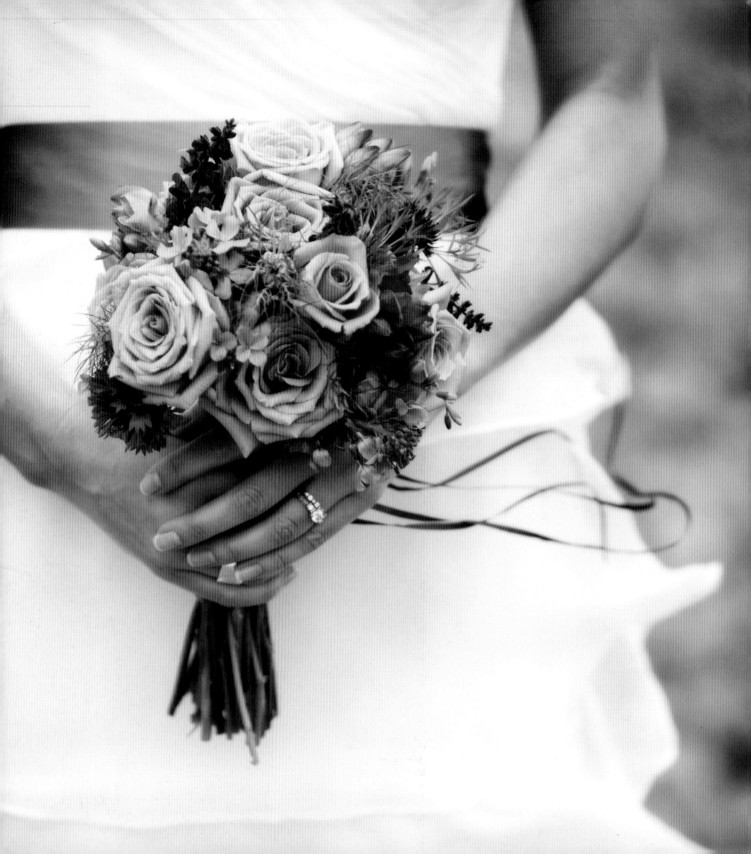

wedding photography
now!

a fresh approach to shooting
modern nuptials

Michelle Turner

LARK BOOKS
A Division of Sterling Publishing Co., Inc.
New York / London

Wedding Photography NOW!
A Fresh Approach to Shooting Modern Nuptials

Library of Congress Cataloging-in-Publication Data

Turner, Michelle R., 1977-
 Wedding photography NOW! a fresh approach to shooting modern
nuptials / Michelle R. Turner. -- 1st ed.
 p. cm.
 Includes index.
 ISBN-13: 978-1-60059-207-2 (PB with flaps : alk. paper)
 ISBN-10: 1-60059-207-4 (PB with flaps : alk. paper)
 1. Wedding photography. I. Title.
 TR819.T87 2008
 778.9'93925--dc22
 2007042171

10 9 8 7 6 5 4 3 2 1
First Edition

Published by Lark Books, A Division of
Sterling Publishing Co., Inc.
387 Park Avenue South, New York, N.Y. 10016

Text © The Ilex Press Limited 2008
Images © Michelle Turner

This book was conceived, designed, and produced by:
ILEX, Cambridge, England

Distributed in Canada by Sterling Publishing,
c/o Canadian Manda Group, 165 Dufferin Street
Toronto, Ontario, Canada M6K 3H6

If you have questions or comments about this book, please contact:
Lark Books
67 Broadway
Asheville, NC 28801
(828) 253-0467

Manufactured in China

ISBN 13: 978-1-60059-207-2
ISBN 10: 1-60059-207-4

For more information on Wedding Photography NOW! see:
http://www.web-linked.com/wnowus

For information about custom editions, special sales, premium and
corporate purchases, please contact Sterling Special Sales Department
at 800-805-5489 or specialsales@sterlingpub.com.

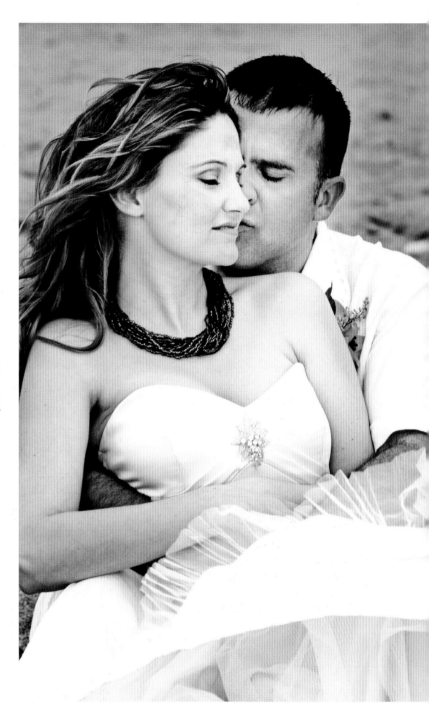

Contents

Introduction

Wedding photography has changed significantly over the last few years. Although the market for traditional wedding photography is still alive and well, more and more couples are looking for something different from what their parents had. Photojournalism is still a buzzword in the industry, but an increasing number of couples want a dual approach—photojournalism combined with interesting portraiture. They want photographs of the two of them interacting with each other and looking spontaneous rather than looking straight at the camera.

Increasingly I am being asked for "Trash the Dress" shoots—post-wedding sessions where the couple will wade into the water or mud or roll around in the grass and dirt in the wedding dress. Couples are asking for "urban grunge" for their wedding portraits. Even the more reserved couples are looking for something different. This makes it more fun that ever to be a wedding photographer—clients are beginning to give their photographers complete creative license, not only with the types of shots, but also with the locations.

Couples want a dual approach—photojournalism combined with interesting portraiture

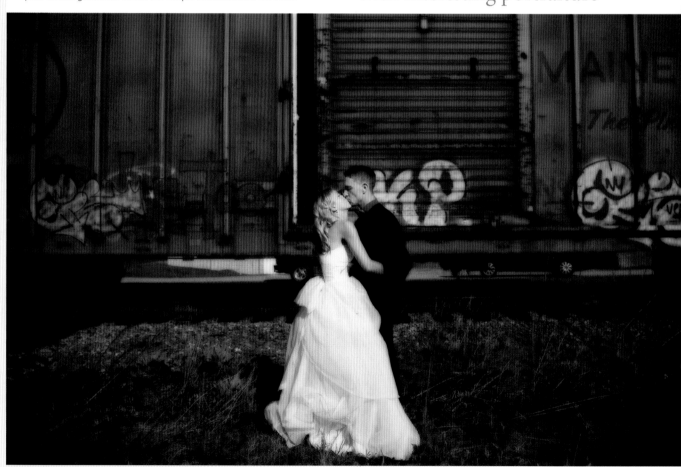

Right: A modern couple in a classic environment. Even in the most traditional of settings it's possible to find new and interesting angles.

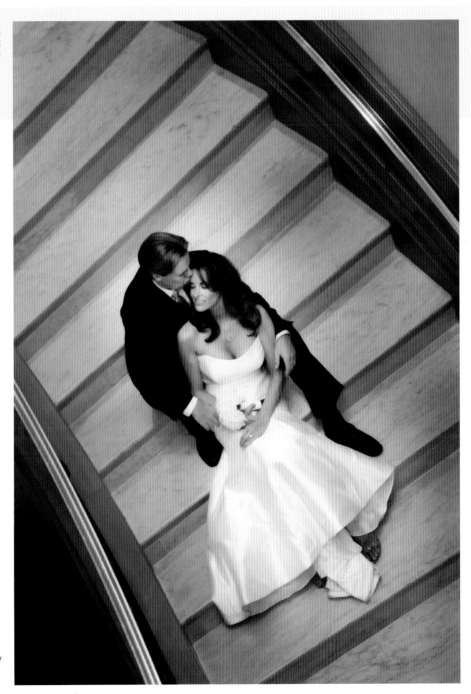

Opposite: Take your couple into different environments for a trendy "urban grunge" look; keep your eye out for well drawn or at least suitably colored graffiti (and remember you can always airbrush out the odd tag).

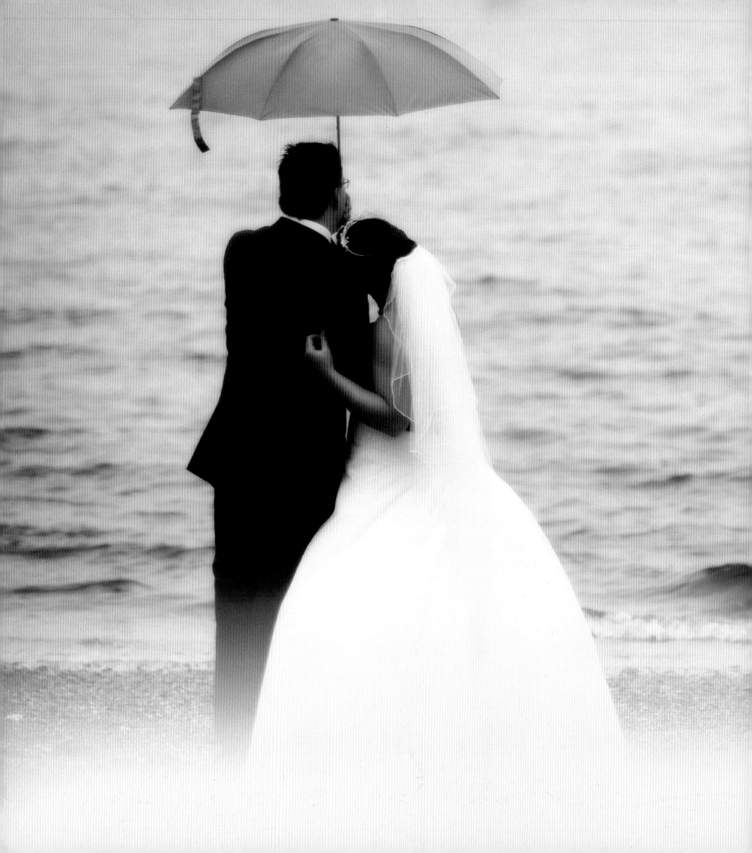

As a photographer, navigating the jungle of gear that is currently on the market can be a daunting task. New cameras and technology are constantly being developed, and it is sometimes difficult to know where to start. There is no right or wrong kit to buy—Nikon versus Canon, prime lenses versus zoom lenses, Mac versus PC—at the end of the day, the only thing that is important is that you buy a system that works for you. You need to have a setup that will help you produce the photographs that you want to produce. Your camera, your lenses, and your computers are only the tools with which you can realize your artistic vision.

The tools

Cameras

Nikon? Canon? Fuji? How many megapixels? The camera store can be a daunting place to visit when you are shopping around for kit. With the focus on photojournalism in today's market, many professionals have forsaken their medium-format cameras in favor of smaller, lighter, and faster SLRs. There are two major players in the professional SLR market—Nikon and Canon, although quite a few professionals use Fuji cameras.

The first thing that you need to determine when you are shopping around for a camera is your budget, as some digital SLRs can cost more than a car. The more expensive cameras (the Nikon D2X and the Canon EOS 1D Mk III, for example) are aimed at professionals and carry many attractive features. These include tougher bodies (metal camera bodies rather than plastic), weather sealing (to prevent moisture seepage), a high frames-per-second rate and a large buffer (to allow you to take many photographs in quick succession without waiting for the camera to "catch up"). However, there are many photographers who use "prosumer" cameras—cameras that are aimed at both the consumer and professional markets (the Canon 5D, the Nikon D300, Canon 40D and Fuji S5, for example). Before deciding on a camera, determine what your budget is. Keep in mind that you are going to need more than one camera to photograph a wedding, since it is good practice to have at least one backup in case of emergencies.

Before deciding on a camera, determine what your budget is

The second thing that you need to think about is crop factor. Nikon, Fuji, and some of the Canon cameras have crop factors. This is caused by the image sensors not being a uniform size, but generally smaller than 35 mm film. That means that if you use a 28 mm lens on a D2X, which has a 1.5x crop factor, it will in practice work more like a 42 mm lens, as the smaller sensor is centrally placed where the larger film would have been. The latter figure is known as the lens's "equivalent focal length." There is a series of fantastic examples on Ken Rockwell's website (*http://www.kenrockwell.com/tech/crop-factor.htm*).

Left and above: This photo was shot at 12 megapixels. The upper detail reflects this, while the lower one is a simulated four megapixel version.

Left and below: The upper version of this image was recorded using a 35 mm sensor which has the same crop factor as traditional film. The lower version shows the result with exactly the same focal length lens on a Nikon D2X (which has a 1.5 crop factor).

Canon EOS-1D
Mk III

The fourth thing that you need to think about is noise. Noise appears in digital images much like grain appeared in film images. The higher ISO you use, the more noise you will see in your images. At this point, Canon has the high ISO noise advantage—you will see less noise in images photographed at an ISO of 3200 on Canons than you will on their Nikon counterparts. Before making this decision, you will need to ask yourself whether you will be photographing at very high ISO levels often, and if you do, whether the noise is going to bother you. All camera systems are similar up to an ISO of about 800, so your personal shooting style will play a big role in determining the direction you should go.

A note here on dynamic range—the measure of obtainable image density from maximum to minimum. Fuji has the dynamic range market covered—I can get more dynamic range out of my S5 than I can out of any of my other cameras. For me, the great skin tones and the dynamic range are of the utmost importance, so I use the S5 as my primary camera body.

All of the major players in the camera market make solid, reliable cameras. They produce files with different color renditions, different noise patterns, and different lens options. The best thing for you to do is find a camera that you feel comfortable with at a price point that you can afford.

The third thing you need to think about is megapixels. Don't be a victim of the megapixel wars; rather, make an informed decision about the file size that you need and proceed from there. Popular wedding cameras range from 4 megapixels to over 12 megapixels. There are advantages to both ends of the spectrum. The Nikon D2Hs is a 4-megapixel camera—the file sizes are manageable enough that you can shoot your D2Hs in RAW and not have to swap out your 1GB memory card every ten minutes. The smaller file size also makes your post-processing easier, as your computer can process a file from a 4-megapixel much faster than it can process a file from a 12-megapixel camera. I own the D2H (although it has been retired from my wedding work) and have been told on several occasions by camera salesmen that you cannot produce anything over an 8×10 in (20.3×25.4 cm) print from a 4-megapixel camera. This is patently false—I have a beautiful 20×30 in (50.8×76.2 cm) photograph from the D2H hanging in my studio that is absolutely gorgeous. What, then, are the advantages to the cameras with more megapixels? Greater detail. My D2X is a 12-megapixel camera, and I like being able to look closely and see all the faces in great detail when I photograph large groups. In the end, it comes down to what you value more—smaller file size or greater detail.

Nikon D3

Lenses

As important as which camera to buy is the decision regarding which lenses to use. In general, I always recommend that photographers buy the most expensive, fastest lenses (lowest ƒ number) that they can afford. Why? Because you could have the best camera out there, but if you don't have good glass it will go to waste.

Prime versus zoom is a popular debate—I use both. The advantage of using prime lenses is that they are often "faster" than zoom lenses. They have a wider maximum aperture than their zoom counterparts, allowing you to choose a very wide aperture of up to ƒ1.4 (for some Nikon lenses) or ƒ1.2 (for some Canon lenses). I choose to shoot on wide apertures anyway because I like the shallow depth of field that it produces—most of my work is photographed at ƒ2.8, 1.8, or 1.4. However, the fast primes are invaluable for shooting available light photographs in low light. If I am photographing in a dark church, I will always use my 50 mm ƒ1.4, my 28 mm ƒ1.4, and my 85 mm ƒ1.8 or 1.4 so that I can shoot the scene without resorting to either a flash or a tripod.

Zooms are convenient simply because they do the work for you

Zooms are convenient simply because they do the work for you. Instead of moving your feet, you can change the scene by zooming in or out. This is particularly useful when you are photographing with limited mobility or you want to quickly photograph a particular

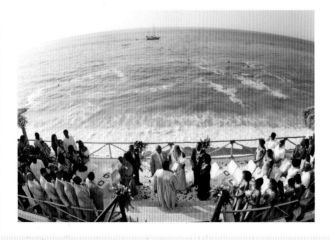

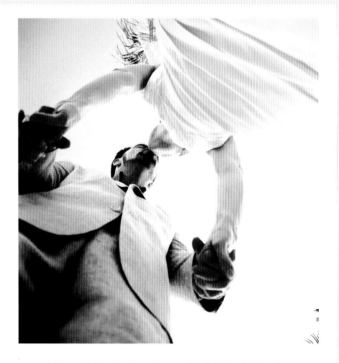

scene with a variety of options. I am particularly fond of my long zoom (80–200 mm, ƒ2.8) because of the flexibility that it affords me. It allows me to stand at a distance and photograph the wedding without being obtrusive. Often my subjects have no idea that they are being photographed, which produces very real expressions. I tend to use my short zoom (17–55 mm, ƒ2.8) when taking formal shots, and during parts of the reception when I want to have the flexibility of deciding whether to go wide or zoom in quite quickly.

The fisheye lens is another tool that some photographers choose to use—it is extremely wide and produces a warping effect around the edges of the photograph. I love to use a fisheye lens to add a bit of variety to my ceremony and reception shots because my 10.5 mm or 16 mm lenses are wide enough to photograph the entire scene. I also use my fisheye for "different" portraiture, although I am always careful to keep my subjects in the center of the frame to avoid warping their faces. If you are not fond of the fisheye look but like the extra width, you can either take a look at the 12–24 mm lenses that are available or purchase software that will allow you to de-fish your shot. There are several products available that will help you to do this, but the best that I have found is carried by DXO (*www.dxo.com*).

Far left: Here is an example of a fisheye shot—notice the rounded horizon. This was taken with the Sigma 16mm on the D2X. I photographed this in manual, knowing that the bright horizon would fool my camera's meter. It was taken at ISO 400, f11, 1/500.

Opposite top: Another example of a shot that I did with the Sigma 16mm on the D200. Once again on manual, ISO 400, at f2.8, 1/1600.

Above: Long lenses are great for photographing children because you can do it without drawing their attention. The same is true for ceremonies, when you don't wish to be obtrusive. Here is a photograph of both—a child during a ceremony. Taken at 200mm with Nikon's 80-200, 2.8 lens.

LENSES

Camera Settings

Once you have your preferred camera and lenses, you will need to decide how to set your camera. There are two big decisions to make here—RAW versus JPEG, and exposure method.

The first decision—RAW or JPEG—is all about image size and quality, and has been the subject of many debates. I use both, because each one offers distinct advantages. Once again, there is no right or wrong choice here. Simply find the method that works for you and use it. Shooting in RAW mode will give you a bit more latitude in your exposure and white balance. Beyond exposure, the camera does not apply any settings to the image—all settings are applied in your post-production workflow. This means that you can set your white balance and tweak your exposure with more flexibility after the image is taken. (Be careful here, though, because if you are photographing on program, aperture, or shutter priority, your white

balance will affect the exposure that your camera chooses.) I shoot in RAW when I am in constantly changing or mixed lighting situations so that I can fine-tune my white balance after the shoot. I also shoot in RAW when I am photographing groups of people with skin tones that vary widely. I find that in JPEG setting my cameras tend to compress the shadows more than I would like, so if I want to retain a lot of the shadow detail I will shoot in RAW. For the most part, I shoot in RAW with my Nikon cameras and JPEG with my Fuji S5.

There are two possible drawbacks to shooting in RAW, but neither is serious when you consider the extra latitude that it gives you. The first is the file size. RAW files, because they save much more image information rather than applying camera settings and compressing the image, are much bigger. This means that you will be changing your memory cards with more frequency, and

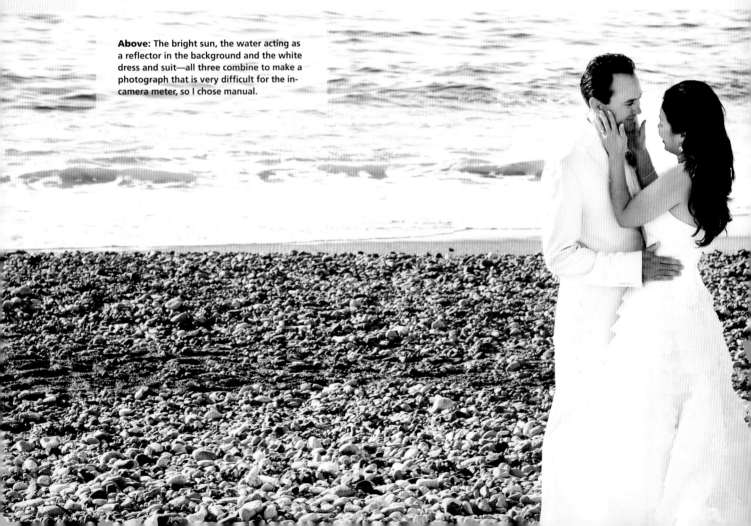

Above: The bright sun, the water acting as a reflector in the background and the white dress and suit—all three combine to make a photograph that is very difficult for the in-camera meter, so I chose manual.

you will be adding time to your post-shoot workflow if you don't have a computer that is fast, with a lot of memory. To put things in perspective, when I shoot a wedding in RAW I usually shoot 20–30GB of images. When I shoot a wedding in JPEG, I shoot about 10GB of images.

The second drawback is the time needed to process the images. Since RAW files have no settings applied, you will need to apply them yourself after the wedding at your computer. If you were not planning on doing any post-processing at all, then RAW probably is not for you. However, most wedding photographers I know do some post-production work on their images, so unless you are planning on little or no post-production work, a RAW workflow need not be any slower than a JPEG workflow.

Shooting in RAW mode will give you a bit more latitude in your exposure and white balance

If you choose to shoot your images in JPEG, you will need to determine the size and the quality of your images. I typically shoot on large fine (meaning that the files are captured at a maximum size with minimum compression). Occasionally I shoot the preparations and reception on medium fine if I am using a 10- or 12-megapixel camera because I simply do not need a large file size for that part of the day. I never waiver from the fine setting, however, because by allowing the camera to compress the JPEGs, you could have problems down the line with JPEG artifacting (jagged patches in your images). I like shooting in JPEG for most of the day on most of my weddings because my exposures and white balance tend to need only a little bit of tweaking in post-production and I like the smaller file sizes.

The second decision that you will have to make is how to set your camera to expose the images. You have four choices: program, aperture priority, shutter priority, and manual. In program mode, you are letting the camera decide how to expose the image. You could end up with a wide depth of field and a slow shutter speed in one shot and then a shallow depth of field and a fast shutter speed in the next. I rarely shoot in this mode because of the lack of control it gives me.

In aperture priority, you set the aperture that you want the camera to use and then the camera calculates the shutter speed. I tend to shoot in this mode about half the time—I almost always want to shoot with a wide aperture to give me a shallow depth of field (pleasantly out-of-focus background and foreground with sharp subjects). I shoot in aperture priority when the lighting is changing, necessitating different exposures from shot to shot

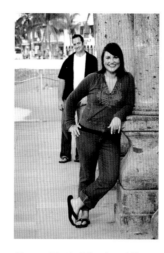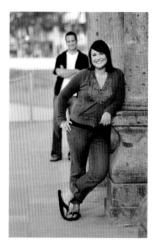

Above: Most of the time, I like to work with a shallow depth of field (a wide aperture—1.8 here), as shown on the right. It draws attention to the subject (the woman) and throws the background (the man and the scene in the back) pleasantly out of focus.

while I am moving around. While my cameras are quite good at determining the exposure, I do constantly "chimp" (look at the image on the back of the camera) to determine that they are doing a good job. I set my image review to flashing highlights mode—this will show me if my camera is overexposing the highlights—and I use my exposure compensation button for more control over how the camera is exposing the image.

In shutter priority, you set the shutter speed and the camera sets the aperture. I use this setting if I am photographing in changing low light and I need to have a minimum shutter speed. Generally I make sure that I am shooting at 1/60th of a second for my shorter focal lengths and about 1/100th for my longer focal lengths. I can shoot down to about 1/30th of a second comfortably for steady subjects, but experience motion blur when I go lower than that. Your ability to handhold at slow shutter speeds may be different—I know some photographers who can handhold down to 1/15th of a second—so make sure you experiment to determine where your comfort level is.

In manual mode, you will have total control over the image because you are setting both the aperture and the shutter speed. I use manual mode about half of the time at every wedding. I shoot on manual when I am comfortable that the lighting is not changing quickly and that I will have adequate time to tweak it if I need to between shots. Generally I use manual for ceremony shots, formals, and reception shots. I like the control that it gives me over exposure and I spend less time checking my images because I have carefully set the camera to expose the image the way that I want it to.

*M*aintaining Your Gear

It is very important that you treat your gear with tender loving care. Be careful not to store it in an area that is too hot or too cold, and send it in for regular checkups. I tend to send my cameras in to Nikon once every year or two to upgrade the firmware, have it cleaned, and make minor modifications and adjustments. I shoot over 60,000 images a year with each of my cameras, and I want to make sure they are in top shape.

You can minimize risk of dust by keeping the back of your lenses clean

That said, there is some maintenance that you can perform on your own. Keeping your gear clean—externally and internally—is one good example. If you change your lenses often or if you own a camera that isn't weather-sealed (most of the cheaper SLRs are not), you may find dust spots on your camera's sensor from time to time. These will look like little grey blobs on your images when you review them—they are often too small to see on your camera's LCD unless you know precisely where to zoom in.

To check for dust on my camera's sensor, I will photograph a white wall or the sky. I set my exposure compensation to +1 or +2 and I stop down to a relatively small aperture (f11 or higher). Once I have done this, I open the photograph on my computer and zoom in to 100%. You are looking for little grey blob or squiggles—the presence of these on the photograph will let you know that your sensor is dirty and needs to be cleaned. So, how do you clean it?

First, let me say that cleaning a sensor is not without risk. Keep in mind that you are not really cleaning the sensor itself; rather, you are cleaning the filter or piece of glass on top of the sensor. However, if you use the wrong tools or the incorrect technique, repairs can be costly. If you are in doubt, take your camera in to a professional or send it in to the manufacturer to have it cleaned.

I choose to clean my sensor myself as I do a lot of traveling and cannot always change my lenses in clean, dust-free areas. I clean it as a matter of course before every other wedding. I also clean my sensor when it gets a few different spots on it, as Adobe Lightroom (more on this later) allows me to clone out dust spots and then copy and paste that change to several different photographs,

effectively eliminating them. However, if I notice a few different particles or if the dust lies right on the horizon line of a lot of my photographs (making cloning more complex), I know it is time to clean the sensor.

I use Eclipse Optic Cleaning Fluid and Sensor Swabs—they are both made by Photographic Solutions Inc. and are available in many camera stores. There are several types of sensor swabs—make sure that you buy the swab that is appropriate for your camera body. Photographic Solutions has a fairly good description of how to clean your sensor using their products on their website (*www.photosol. com*). There is also an excellent description of some of the other products available (and some photographs that show you what these dust particles look like on your photographs) at *www.luminous-landscape.com*—search the website for the word "sensor"—and at Thom Hogan's site (*www.bythom.com/cleaning.htm*).

Keep in mind that sensor cleaning can be fairly easy and painless, once you get the hang of it. However, any sensor cleaning that you do on your own cameras is done at your own risk. You can minimize risk of dust by keeping the back of your lenses clean and free of dust and by changing your lenses in a clean, dry, dust-free area.

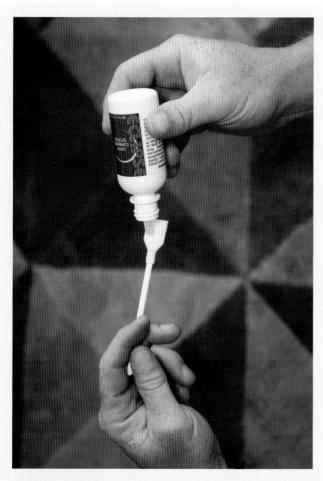

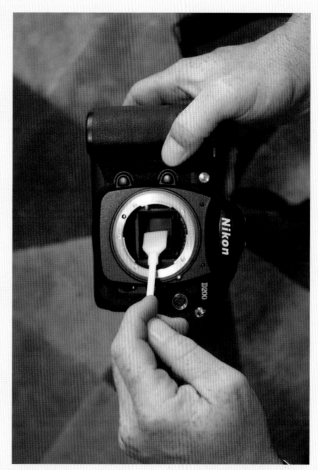

Above: Gently apply cleaning fluid to the specialist swab. You will not need a lot, so be careful.

Above right: Set the camera to its special cleaning mode (check your documentation) and move the swab across the sensor area. The sensor is an incredibly delicate component, so not apply any force. Let the swab do the work.

Right: The Nikon D300, in common with most new SLRs, has the ability to clean the sensor automatically, in this case by vibrating it.

Flash

Most of the time, I try to use the light that is around me to photograph a scene. That is, I try to use the existing light without adding any additional light to the scene. However, there are times when the addition of light can really enhance the photograph—for example, when I am photographing a backlit scene and I want to retain detail in both the foreground and the background, or when I am photographing at night and there is little or no existing light.

Some DSLRs—the Nikon D200 and the Nikon D80, for example—have an attached, pop-up flash. You cannot point the attached flash in one direction or another—you are limited to having the flash point straight ahead. For this reason I never use the camera's pop-up flash—I always attach an external flash. Since I bounce my flash to diminish the harshness that comes from direct flash, it is essential that I have control of the direction of the light. Therefore, I have invested in a number of speedlights that can be used on- and off-camera, including several of Nikon's top-of-the-line speedlight, the SB-800.

There are times when direct flash is a necessity

Most of the time I use the speedlight on-camera with a diffuser attached. There are several great diffusers on the market—I currently use Peter Gregg's A Better Bounce Card (*www.abetterbouncecard.com*) and it gives me fantastic results. When I am using flash I always use my camera in manual mode with my flash in D-TTL. My standard settings for a well-lit reception are ƒ5.6 to 1.4 (depending on the available light) at 1/60th or 1/30th of a second at 800 ISO with my flash pointed straight up and my A Better Bounce Card bouncing the light forward. Usually I am able to retain enough ambient lighting at those settings so that the atmosphere of the reception is not obliterated by the flash. If it is really dark I may change my settings to a wider aperture or to 1600 ISO, but I like to remain at 1/60th or 1/30th of a second.

I also like to bounce my flash off different surfaces to direct the light. When I bounce light like this, it is often done without a diffuser attached because I do not want to send a lot of my light forward. You can bounce light off walls, ceilings, and floors to produce beautifully lit photographs with little or no flash shadow and can often simulate the look of soft window light. You need to be aware of the color of the surface that you want to bounce your light off, as this can affect the color of the light that bounces back on your subject. Neil van Niekerk has some great tutorials regarding the creative use of flash on his website (*www.planetneil.com*).

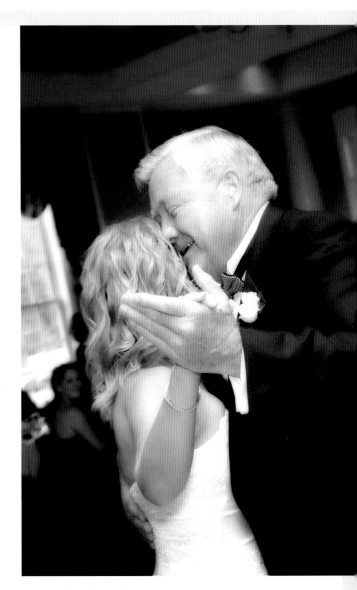

Above: The ambient lighting in this room created harsh shadows across the father of the bride's face. By adding some flash, I was able to lift the shadows and show his beautiful expression as he danced with his daughter. This was taken on manual at 1/60, ƒ5.6.

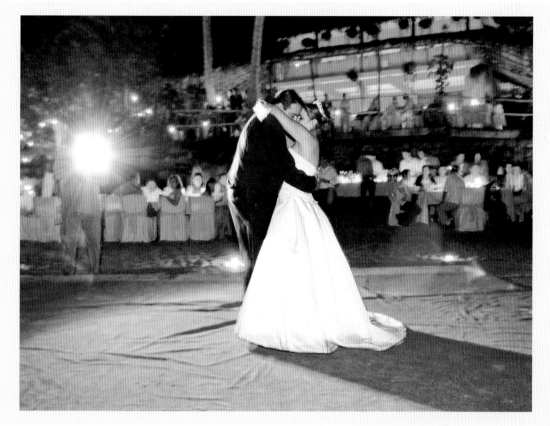

Left: Here, I shot on manual at a shutter speed of one second and an aperture of 4.0. The flash allowed me to freeze the motion while the one second shutter speed allowed some of the ambient light to be visible.

Below: This was shot on manual at 1/20th of a second with flash. The flash has frozen the motion of the bride and groom while the long shutter speed has kept the flash from overpowering this photograph.

Of course, there are times when direct flash is a necessity. When I pose a bride and groom in front of a sunset, for example, I usually use direct flash dialed down to expose the scene properly. When photographing a sunset scene, meter for the background. Set your camera to those settings in manual, then add your flash. I usually dial my flash to -2/3, but you will need to play around with this to find the correct flash compensation.

There are also times when I like to use multiple speedlights to produce more directional light. I often use these during a reception for dance-floor shots to give a more three-dimensional quality. My Nikon SB-800s are able to communicate with one another in Master/Slave mode, allowing me to fire my camera and have the on-camera flash and a second flash (placed somewhere on the dance floor or held by my assistant) fire at the same time. If your flashes are unable to communicate in this way, there are several third-party devices available to enable them to do so, including the Pocket Wizard (*www.pocketwizard.com*).

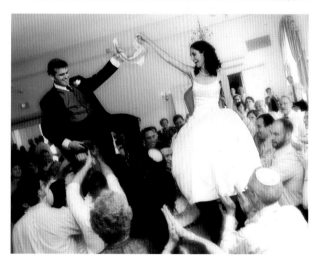

Several specialty products are available that can be very useful to you and can greatly enhance the variety of photographs that you can provide to your clients. The three specialty products that I use on a regular basis are reflectors and scrims, infrared cameras, and video lights.

The video light is an indispensable tool that we use at almost every wedding

Most of the time I try to find a spot with a good background and nice light for photographs. Occasionally, however, you need to make a choice between the two. I almost always opt for the nice light, but often clients will be expecting the nice background.

Occasionally a reflector or a scrim can help the light in such situations. I use a reflector (always a silver or white reflector—I don't use gold because I don't want the light that I reflect on my subject to have a color cast) to bounce light onto a subject's face. There are reflectors in many different shapes and sizes that are on the market—you can also use other objects. A white sheet (or a white dress!) can be used as a reflector, as can white buildings. I use a scrim when I want to soften harsh light that falls on a subject. When the bride and groom want portraits on the beach in harsh light, a scrim can often be useful. A scrim is a translucent panel that is placed between the light source and the subject. It will soften the light and reduce some of the high contrast caused by the light in the scene.

Infrared cameras can be fun tools that add variety to your portfolio. There are several Adobe Photoshop actions that can simulate the look of infrared photos, but few of them come close to the look of the real thing. Infrared cameras and filters are available, but if you have an older DSLR around it is possible to have it converted into an infrared camera. We had an older Nikon D100 in the studio that we never used, so we had it converted. There are several places that will convert DSLRs into infrared cameras—we had ours done at *www.lifepixel.com* and we were very happy with the results.

The video light is an indispensable tool that we use at almost every wedding. It is a great alternative to flash, and the nice thing is that you can see what the light is doing before you take the photograph. We like to use the video light in creative portraits done in low light and during the dancing at the reception to take backlit photographs or to add more dimension to the light in our photographs. We use a variety of video lights—I use a small Sunpak when I need to hold the light and photograph at the same time, or when we want to travel without the extra weight that comes with a bigger video light. We also use the Lowel iLight and the idLight—both have optional barndoors, and the idLight has a dimmer switch. You need to purchase an external battery pack if you are not sure that you will have access to a plug.

Left: This is a simple videographer's light without any additional equipment attached. It is small enough to be very portable, though the stand can be more cumbersome.

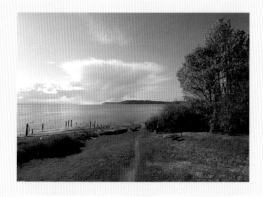
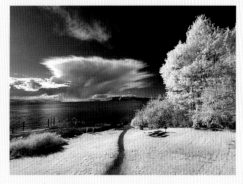

Left: A scene shot using a standard camera and then with one converted to infra-red. Notice that grass and leaves reflect a great deal of infra-red light, hence appear very bright.

Flash
It goes without saying that a camera-mounted flash is essential.

Soft box
Optionally placed above the flash head to create a diffused light from a small space.

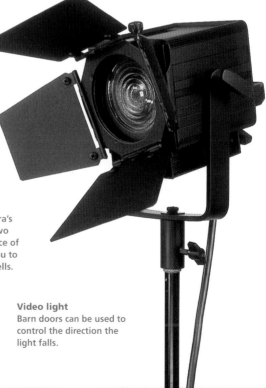

Battery Grip
Extends your camera's life by cramming two battery units in place of one, or allowing you to use store-bought cells.

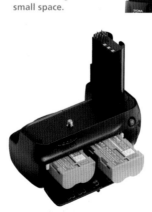

Reflectors
Ask your assistant to hold these and reflect light onto the unlit side of your subject.

Video light
Barn doors can be used to control the direction the light falls.

Computers

As digital cameras evolve, file sizes are getting bigger and bigger. Add RAW to the mix and a huge buffer, and you can end up with tens of gigabytes of images. What does this mean for your computer setup? It means that unless you want to spend a lot of time waiting for your images to process in your post-processing setup, you will probably want to invest in a good computer.

Mac or PC? I have used Macs for as long as I have been a professional photographer, so I have no personal experience with PCs. However, I can say that I have worked side-by-side with another photographer at a seminar—she was on a PC, I was on a Mac—and we opened the same images on our machine and processed them at similar speeds. Whether you go with a top-of-the-line Mac or PC, you will have similar results. The operating systems are different, so it all comes down to what you are comfortable with. When buying a new computer I always make sure that I upgrade the RAM (memory) and the hard disk—I get the most that I can afford. This will speed up your processing times considerably. Since computers are always evolving and getting faster, it is a good idea to test out the computer that you are considering. You can do this at most computer stores. Many of the computers have Adobe Photoshop installed—I actually bring in a

CD of my images to run through different programs. (Note that, if you have bought a new Mac with an Intel processor, it is worth upgrading to Photoshop CS3 or later, since this is the first version to be able to fully take advantage of the Intel processors and will be much faster. Click on the Apple in the top-left of the display and choose *About this Mac* from the menu to check.)

What else do you need? Well, unless you are planning on archiving all of your images on your computer's main hard drive, you might consider some other storage options, such as a RAID setup or a number of external hard drives. After processing my images, I always back them up to two external hard drives and burn a minimum of three DVDs for each shoot. I have never had any problems with either type of storage, but I know of many photographers who have lost images because they only stored them in one location. Better safe than sorry.

You might also consider a dual monitor setup for your workstation. When I work in Photoshop I like to have my actions and layers palettes readily accessible, but I also like to have my image taking up the maximum amount of space on the screen to make editing easier. Often, if I am only looking at a portion of the image at a time, I find that I will over-edit or under-edit the image and will have to go back to the drawing board once I scroll around

Above: Laptop computers like this MacBook Pro are useful for downloading images on site.

Above: Wacom art pads provide pen-like tools which make pointing on the computer more natural.

Above: Combine your desktop computer (here an Apple Mac Pro) with as large a screen as your budget will allow.

Above: Well-designed desktop computers make it easy to upgrade components like the hard disk(s) or the memory. This, in turn, extends the life of your machine.

and look at the rest of the image. This is one of the reasons I hate editing images on my laptop—I have a 17-inch screen, and it still isn't big enough to accommodate the way that I edit my images. I have found a great workaround with a dual monitor setup—this

Make sure that you calibrate your monitors on a regular basis

allows me to have my images open on one monitor and have my palettes and other useful tools on the other screen. Whether you choose one monitor or two, laptop or desktop, make sure that you calibrate your monitors on a regular basis to ensure that the way that your image appears on the screen is the way it will appear on another calibrated screen or in print.

Software

Once you have captured your images, you are going to need a way to process them. The specific programs that you need will depend on what type of image you shoot (RAW versus JPEG) and what you plan to do with the images. There are many fantastic RAW conversion programs out there—Adobe Camera RAW, Capture 1, Bibble Pro, and Adobe Lightroom are among the most popular RAW conversion programs. They each have advantages and disadvantages, and fortunately most of them have trial periods so that you can test them out and see which program you like best. When I evaluate programs, I take the same set of images and process them through each program. I try to find a program that is intuitive for me that produces the results I like best.

All of these programs are excellent, but I have settled on Adobe Lightroom for my RAW conversions and JPEG manipulation. I like Adobe Lightroom because I can manipulate my RAW and JPEG images side by side; I find the interface user-friendly, and I like the output options that it provides. The different modules, crop modes, and spot removal speed my workflow along. Since I have been doing my initial edits in Lightroom I have cut my workflow in half because I can do everything that I need to do (apart from complex image manipulation) in this one program.

Photoshop is certainly an indispensable tool for most photographers

The most common program for image enhancement and manipulation is Adobe Photoshop. Photoshop is certainly an indispensable tool for most photographers and provides a nice replacement for the darkroom of the film days (without the nasty chemicals). All of my complex image manipulation and final preparation for print and web (including resizing and sharpening) is done in Photoshop. The nice thing about Photoshop is that later versions (CS2 and CS3) include Adobe Bridge and Adobe Camera Raw—an excellent image management program coupled with a RAW converter.

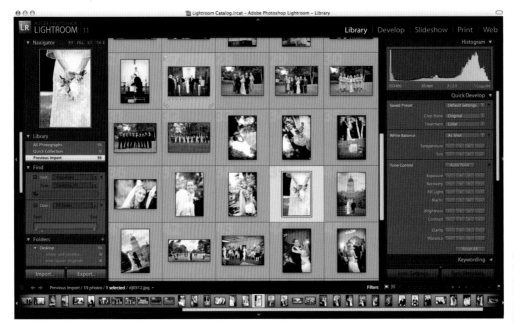

Left: Lightroom works as both a cataloging program and an image editor, making it an instant hit for wedding photographers who have to process many images quickly.

Left: Adobe Bridge allows you to view thumbnails of your photos, take a closer look at any you choose, and examine the metadata to see what the camera settings were when you took the shot.

It is also essential to have a piece of software that will help you calibrate your computer monitor. I rely on Spyder by ColorVision to profile my monitors, but there are several other good systems out there, including GretagMacbeth Eye-One, ColorEyes Display, and Monaco Optix XR Pro. Whichever system you decide to go with, you should be calibrating your monitor every month or so to ensure that your prints look their best.

There are a few other pieces of software that I use, including specialty programs to reduce digital noise and enlarge images. When I shoot at an ISO of 1600 or higher, I will often use noise reduction software when I prepare the photographs for enlargement. I use Neat Image, but Noise Ninja, Noiseware, and DxO are also very good. Depending on the software, you may be able to find profiles for your camera at each ISO, and then tweak them to suit the individual photograph. I also use software to help me enlarge my images when I am going to make a really large photograph (30x40 or larger). I have been using Alien Skin's BlowUp and really like the interface, but it is a bit pricey. I also like ResizePro (a plugin from Fred Miranda's website)—it is significantly cheaper and you can purchase a program that is specifically tailored for your camera model.

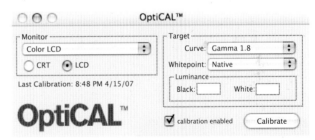

Above: OptiCAL calibration settings require you to indicate the kind of monitor you are using and target Gamma before calibrating.

Right: An Eye-one color calibration tool in use.

Shooting a wedding can be a daunting task unless you know what to expect and have a plan. While every wedding is unique, there are many similarities and your day can run like clockwork if you know when things are going to happen. That is why it is important to be in communication with the couple regarding the details of their wedding day—the times and locations of different events, how they are travelling between locations, how much time they are leaving for different photographs, and how the different locations will be lit. If you know as much as possible about the day plan, any issues can be addressed well in advance of the wedding rather than on the day itself.

Live action

Engagement

I really enjoy engagement photographs because they give me a chance to get to know the couple and build a rapport with them. It is also an opportunity for a photographic trial run, and it gives me valuable information about the couple. Does the bride fidget with her hands? Does the groom have a lazy eye? Are they blinkers? Do they cuddle up together naturally, or does it take a bit of coaxing? Are they comfortable in front of the camera, or are they nervous?

The engagement session also gives the couple a chance to get to know me and my style. Up until this point, they have seen my images, but they don't know how those images are captured. They don't know what to expect, and sometimes they are anxious about having their picture taken. The engagement session gives them a chance to have fun with me and get excited about their photographs on the wedding day. It also gives us an opportunity to create beautiful images in an environment that is not stressful—there are no time constraints, there are no guests to worry about, and emotions are not running high.

Are they comfortable in front of the camera, or are they nervous?

My engagement sessions usually last two hours. They may run over if we are travelling to a few locations or if we really get in the groove. I tell the couple how long engagement sessions usually last so that we are not pressed for time. Because I like to do on-location shoots using available light, I try to schedule my sessions for late afternoon, about two hours before sunset. That way, the light is becoming better toward the end of the session as they are warming up to each other and to me.

I also give my couples advice on what to wear. While I don't give them specifics, I do make sure that I give them some guidance on this point. Many couples will make sure that they look good individually, but they don't worry about looking good together. He may wear his favorite shirt, which may happen to clash with her most flattering dress. By talking to them beforehand, I usually avoid this pitfall. I tell them that while they don't have to match, it is good for them to wear clothes in the same color family without overwhelming patterns or stripes. I like my couples to be relaxed, and wearing clothes that they can move in or don't mind sitting on the ground in can really help, so I steer them toward comfortable clothing options.

I always start out with a few standard poses. These never end up being our favorite photographs, but they work to loosen the

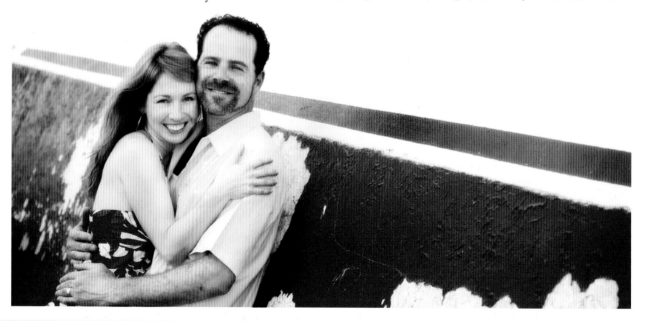

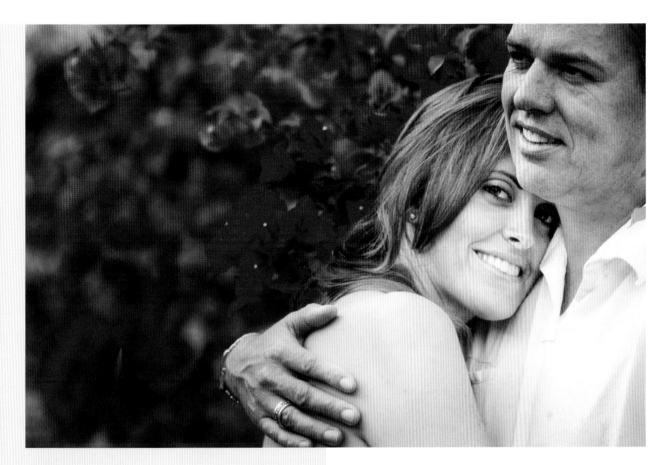

Opposite: This photograph was composed so that the lines lead you directly to the couple—even after looking away from their faces at the other parts of the frame, the clear lines lead your eyes back to them.

Above: This pose is ideal when the bride is very comfortable looking into the camera but the groom is less so. The tropical flowers add a sense of location to the shot.

couple up. Then I move on to prompted shooting—I'll give them instructions (such as "take a walk" or "sit on the bench and chat" or "go buy a coffee and sit at the café table together") and then I throw on a long lens and just photograph them being together. Some couples tell me that they even forget for a moment that I am there because they are just having fun. Often I am able to simply observe and photograph them from afar and then move them on to the next location and do the same thing all over again. However,

some couples will need a little bit more direction. These couples never forget that you are photographing them, and feel awkward or fidget unnaturally because they know you are there. With these couples, I tend to prompt them a little more and to be more hands-on, giving them more detailed instructions. For the most part, though, even the most reserved couples enjoy the engagement session and we are able to get some great shots.

I also enjoy the engagement session because it gives the couple a chance to see how I look at different locations. For example, we may be walking in a beautiful park and I may see some great light in a back alley, or a visually interesting wall behind a dumpster. Even though they have seen my portfolio, most of them don't imagine that they are going to be photographed in a back alley. Once they see and love the results, they are willing to give me creative license during their wedding day as well, foregoing the technically beautiful but visually uninteresting backdrops in favor of something a little less mainstream and perhaps more grungy.

Boudoir

Many brides request a boudoir shoot, either before or after the wedding. Some of them want to give tasteful, suggestive photographs to the groom on their wedding day or anniversary. I offer an on-location boudoir shoot—I either go to their house or rent a hotel room with big windows. The key is comfort—I want these women to relax, and I have found a studio to be a very sterile, uncomfortable environment for this type of shoot.

First, I suggest a wardrobe. Matching lingerie, cute sleepwear, the husband or fiancé's shirt and tie—anything that makes her feel sexy. I will also give the bride guidance on hair and makeup—for the most part, suggesting that she leave her hair down but uses more makeup than usual. For boudoir shoots, the eyes are important, and you should ask the bride to pay special attention to her eyes when applying makeup.

I want my bride to feel and look beautiful in every single photograph of herself from this type of shoot, so I will often ask her before the shoot whether there are any parts of her body that she might want to emphasize or de-emphasize in the photographs. I also show her a selection of boudoir photographs to see what she likes and what she doesn't—some brides are willing to reveal more than others, and I want to make sure that I have a good idea what the bride is comfortable doing.

I tend to do shots that are more suggestive than revealing for our boudoir sessions. I use window light exclusively for the majority of the shoot, photographing with a prime lens (usually a 50 mm

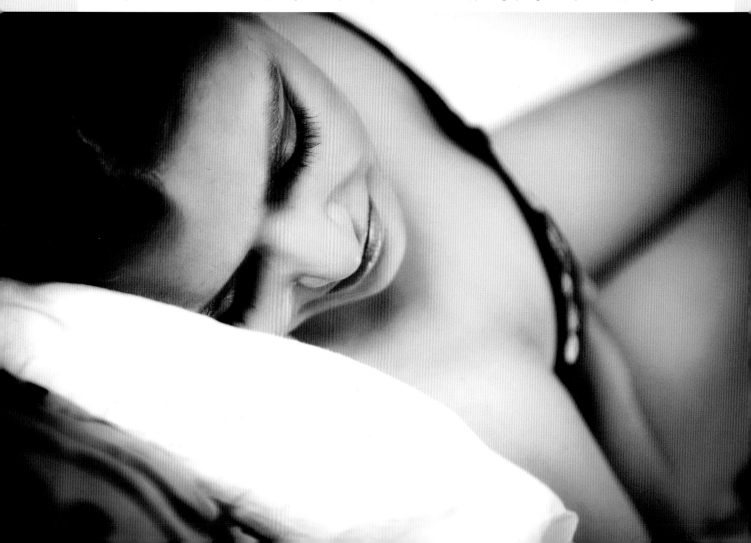

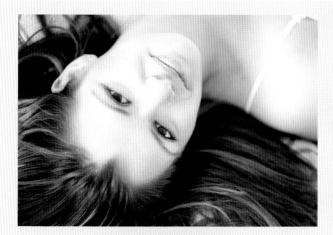

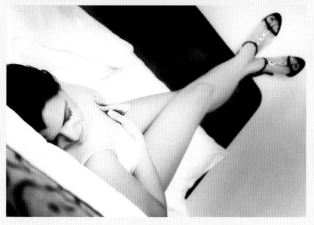

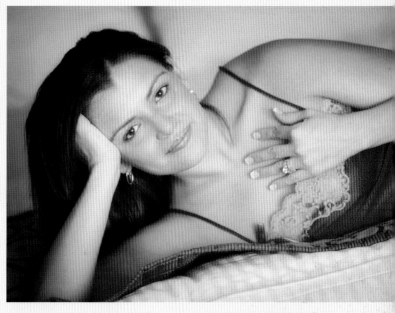

Top left: Flattering shots often occur when you get directly above and shoot down. I like to highlight the hair as so many brides will put it up on the day.

Left: This is a pose that is flattering for virtually any woman—raising the legs up and crossing them will make them look long and lean.

Top right: By showing the engagement ring, you can add a sense of time and purpose to the photograph.

Opposite page: I used a very shallow depth of field (f1.8) to bring out her eyelashes and give just a hint of the body beyond. The vignette applied in post processing draws the eye in, too.

f1.4 or an 85mm f1.8) shot wide open. This produces beautiful, out-of-focus areas that are suggestive and flattering because they are not too sharp. I am very mindful when I pose women in lingerie—I make sure to photograph them from flattering angles, and often photograph them from above to elongate their necks and thin them out. I use chairs, beds, and sofas as props and I tend to photograph them where they are most comfortable. I have them change outfits every five or ten minutes, and I maintain a running conversation with them, constantly giving them verbal feedback. By the end of the shoot, the bride is usually laughing and joking with us and more willing to play with the camera.

I try to emphasize the eyes, mouth, and wedding ring, often using selective focus to draw more attention to these areas. I also bring candles to boudoir sessions because I like to photograph

the bride during part of the shoot by candlelight, which is soft, flattering, and sexy. It also subtly alters the mood and will often prompt the bride to give me different expressions.

Some brides are willing to reveal more than others

I tend to do a bit more post-processing with my photographs from boudoir sessions. I add a lot of Gaussian Blur and grain to the photographs, sharpen the eyes and eyelashes, and add a subtle vignette to emphasize certain areas and to de-emphasize distracting elements in the room. I also do a lot of skin smoothing and subtle body toning.

Setting and Location Details

Most of the time, the bride and groom have put a great deal of thought into the location of their wedding. I think that it is just as important to capture photographs of the setting as it is to photograph the actual events. A photographer I really admire, David A. Williams from Australia *(www. davidwilliams-heartworks.com)*, illustrated this point for me by setting up a slideshow of his images from a wedding at which he acted as the second photographer. Only one or two of the photographs had a face in them—the rest of the photographs captured the setting only: the gate in front of the castle where the reception was being held, the flowers on the front lawn, the line of cars outside as the guests started arriving. When I finished watching the slideshow, I hadn't seen the face of the bride. I hadn't seen the face of the groom. I didn't know how many attendants they had at their wedding, but I could have told you exactly how it felt to be at that wedding.

Left: The door of the church is almost always decorated, but a photo might be the only chance the bride has to see it properly.

Above: Although the fisheye adds curvature to the architecture, I find that it adds interest to the photograph.

Opposite: I try to capture the flowers where they are placed, even if that means crouching next to them for the best shot.

A sense of place is often very meaningful to the couple

You see, too often we focus on the expressions of the day and nothing else. Don't get me wrong, expressions are an incredibly important part of the day, but they aren't the only part. The bride and groom have chosen their location carefully—often, it is the very first decision that they make after they decide to get married. It is important to capture that location, from the architecture of the church to the wreath on the doorway and everything in between. This will give your wedding coverage a sense of place that is often very meaningful to the couple.

I try to arrive early enough in the day so that I can photograph the setting before I ever see the bride. I photograph the spot that they have chosen for their bridal preparations, the location of the ceremony, and (time permitting and if it is close by) the location of the reception. Not only does this gives me a great opportunity to see how things are set up, but it also gives me a chance to photograph the buildings and some of the details that are a part of the setting. I also take this opportunity to scope out some locations for photographs if I haven't already done so—while I am photographing, I poke around the grounds, looking for hidden nooks and interesting spots, conscious of how the light is going to change.

This is one of my favorite opportunities to use my fisheye lens. I don't mind the curvature of the lens—I am not photographing for an architectural magazine, and I like the rounded edges of the photograph. I don't mind if my buildings are curved—for me, it adds an element of visual interest to the photograph, and, depending on the specific lens that you use, can capture the scene in its entirety. However, if the fisheye look doesn't appeal to you, ultra-wide lenses are available (there are several brands of 12–24mm lenses, for example), or you can fix the perspective of your fisheye lens during post-production in Photoshop (*www.dxo.com* also has a plug-in that can help you do this).

*B*ride's Preparations

Bridal preparations are usually a flurry of activity—hair, makeup, dresses, bridesmaids and relatives running to and fro. Emotions are running high. You tend to see it all during this part of the day, from nervousness to excitement and everything in between, and you can often capture some fantastic photographs of the interaction between the bride and her mother and the bride and her bridesmaids during this time.

I always try to photograph the dress hanging up during the bridal preparations, sometimes photographing it by itself, and sometimes using it as the foreground element with the hubbub in the background. I'm not afraid to ask the bride if I can move her dress if she has it hanging in a closet or shrouded in plastic and the bride is usually happy to comply. I also try to photograph the bride's shoes before they get scuffed and dirty, most of the time with the bride's dress in the background.

During bridal prep I use a combination of lenses—I usually use a wide-angle or a fisheye lens on one camera body and my 85 mm ƒ1.4 or ƒ1.8 on the other camera body. I use the wide angle to capture the scene as a whole and the 85 mm to capture individual faces and emotions. I shoot these lenses wide open on either aperture priority or in manual mode at a high ISO so that I can photograph in the often poorly lit environment without a flash.

During bridal prep I use a combination of lenses

Makeup application and hair tend to take a long time, and though I take some photographs of both these things, I don't photograph them nonstop. I ask the bride what time she is planning to put on her dress and then I arrive about an hour before that time. That usually gives me ample opportunity to photograph

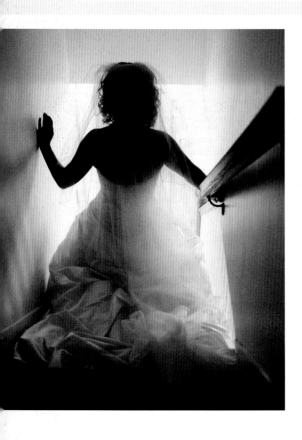

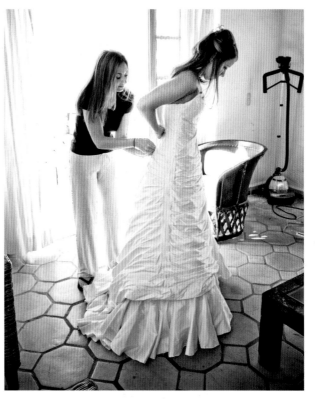

Far left: Though the background is bright and the foreground dark, I chose not to use flash, instead creating a silhouette.

Left: This is a nice, safe shot that every bride loves and chooses for her album, even if she is wary of some taken at other stages of dressing.

Top right: Be ready to capture emotional moments between the bride and her mother or bridesmaids as the dress goes on!

Right: I used a wider angle here to include all of the bridesmaids, each of whom was doing her part to smooth out the bride's dress.

the end of the hair and makeup session, followed by the detail shots of the room. If I don't have a second photographer working with me, I often float between bride prep and groom prep until the bride is ready to put on her dress. My general policy is to start photographing the bride getting dressed as soon as she is completely covered, but I usually ask what the bride wants as some will want photographs in their lingerie as they step into the dress.

For the most part, during bridal prep I am trying to capture the interaction of the women—I look for special moments shared between the bride and her best friends, the hug that the mother gives the bride, the expression on the bride's father's face when he sees her in the dress for the first time. Many brides and bridesmaids will do a toast before they leave for the ceremony, and this is often an emotional, impromptu speech made by the bride's best friends.

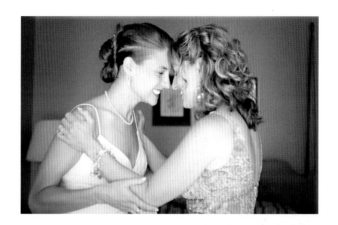

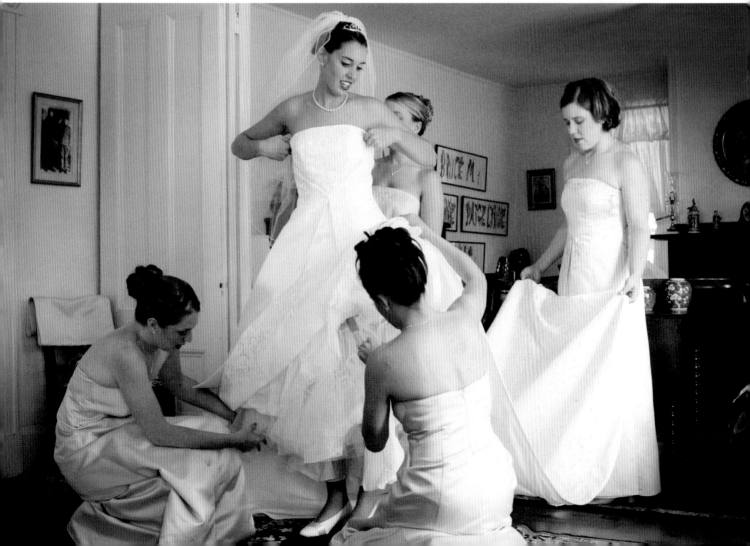

he Bride's Details

The bride has usually put a lot of thought into the bridal details, and I try to capture as many of them as I can. The first of these is probably the dress and accessories, which I always try to photograph during the preparations (see page 34). I keep an eye out for some of the more intricate details, too. An elaborate lace border on the edge of the bride's veil, the pearl buttons up the back of the bride's dress, the bride's engagement ring—all of these are details that add to the bride and groom's wedding story, and I try to capture them all. It helps to look at each item and think what significance it might have to the wearer.

Look at each bridal item and think what significance it has to the wearer

I also take this opportunity to look for things that may be important or personal to the couple—signs that they have put up to direct their guests to the wedding, post-it notes on the door that say "Shhhh! The bride is sleeping!," flip-flops that have been left at the door that say "Bride" on the sole, the note in the

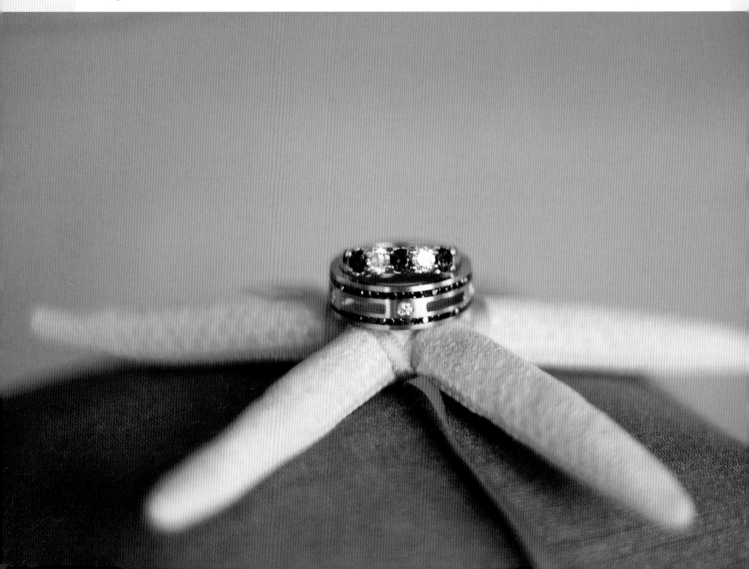

Above: Be sure to look for interesting and unique details. This bride had spent several hours on her hands, so I wanted to show them. Sometimes you can get a shot like this when she is showing details to other people. If the shot doesn't happen naturally, though, don't be afraid to ask her.

Left: In this case, the starfish (which was a theme in this wedding) was actually a part of the ring pillow, so I didn't have to look far to integrate the theme and color of the wedding into the ring shot.

Right: Don't neglect the veil and the back of the bride's head. I always try to get a few shots of the bride from the back.

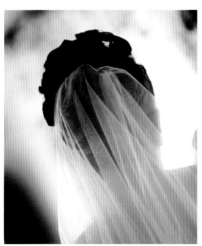

flowers that the groom has sent to the bride that morning—and try to capture all of these things in their natural settings. Upon seeing these images after the wedding, couples will often remark that those scenes made them remember what they were thinking or feeling the morning of the wedding or will remind them of something funny that happened.

Groom's Preparations

While bridal preparations are similar from wedding to wedding, the groom's preparations are vastly different from wedding to wedding. Most grooms do not spend anywhere near the amount of time getting ready that the brides do, so they will fill their morning with various activities. Some grooms will go golfing, some watch sports on television, some go to a bar, some sleep. But we always try to photograph them doing whatever it is that they choose to do on the morning of the wedding. Our cameras are time-synchronized, and most brides will get a kick out of looking at the proofs and being able to see that while she was applying her makeup her groom was watching cartoons and drinking a beer.

All of our grooms like to take a "Reservoir Dogs" walking shot

The groom can often get ready in a matter of minutes and will have time to burn, so we like to take this opportunity to take some fun shots of him and his groomsmen. Almost all of our grooms like to take a "Reservoir Dogs" walking shot—they love this photograph because they can all try to look tough as they walk toward the camera. The grooms are usually less worried about getting dirty before the ceremony than the brides are, so they are often willing to find cool locations for their photographs.

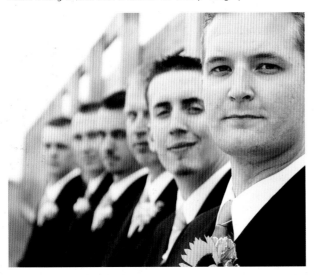

The groom almost always arrives at the ceremony site well before the bride, so if I have my second photographer with me I will send him with the groom to the ceremony to photograph his nervous anticipation or elation as the ceremony approaches. Some grooms will welcome their guests as they arrive, and this is a great time to take some candid emotional shots of the groom with his family and friends. We like to use a long zoom lens at this time (an 80–200 mm, ƒ2.8, or something equivalent) so that we can capture the photographs from afar without the awareness of the groom.

Far left: Using a shallow depth of field (at an aperture of f2.8) we were able to create a photograph where the groom, who fills a lot of the frame, is in sharp focus and his groomsmen recede out of focus.

Near left: Capturing your subject as he looks out of a window gives a flattering light and a sense of anticipation.

Right: The "Reservoir Dogs" walking shot is one almost all grooms like, but it doesn't always need serious expressions.

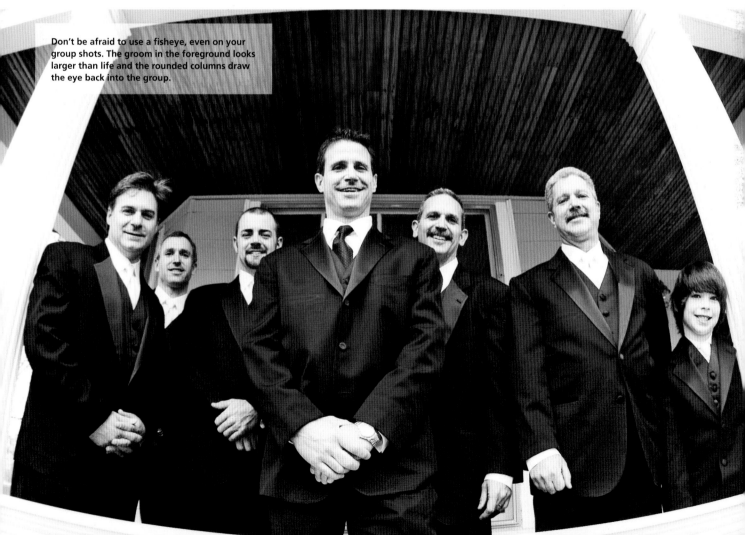

Don't be afraid to use a fisheye, even on your group shots. The groom in the foreground looks larger than life and the rounded columns draw the eye back into the group.

Ceremony Location

I have photographed ceremonies in all kinds of places—from a white sandy beach at high noon to a candlelit hall with low ceilings, and everything in between. I like to know well before the wedding day all the details about the location and how it is going to be lit, because it will affect which lenses I choose to photograph the ceremony and what equipment I bring with me.

I usually do not use a tripod during the wedding day; however, during certain candlelit, extreme low-light ceremonies I may choose to bring one. I like to capture the ceremony using ambient light, so for this type of ceremony I will choose prime, ƒ1.4 lenses. My 85mm is my favorite because it has beautiful bokeh and allows me to maintain some distance from the bride and groom while handholding the camera. I don't usually use flash during a ceremony, but if the processional has strong backlighting from an open door behind them I may choose to add a little bit of fill flash. This brings up the shadows in the bride's face without completely blowing out the background.

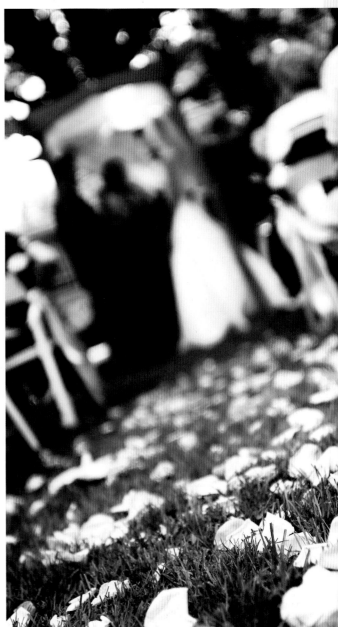

If the ceremony is inside, I like to have a general layout of the church or building. Sometimes there are balconies or doors to the side of the altar, and I like to make sure that I know how to get to them and if they are going to be unlocked. In churches that do not have a center aisle, I need to make sure I know whether the bride will be walking up the left or the right side, and I like to choose an alternate vantage point (other than the center aisle) for the exchange of rings and the kiss. If there is no balcony or ideal side location, I may need to bring a step-stool to use at the back of the church to allow me to shoot over the heads of the guests.

I don't usually use flash during a ceremony

If the ceremony is outside, I will usually have more flexibility and mobility. If there is strong backlighting I may need to use a little fill flash to lift the shadows in the faces. Typically I use existing light and a long zoom lens for most of the ceremony interspersed with my fisheye lens to capture the entire location. I like the long zoom on aperture priority, wide open, because it allows me to stand at a good distance from the bride and groom and to separate them from the background effectively.

Far left: Make sure to take photographs of the musicians. I usually try to incorporate the bridal party or other details in the background, especially since most brides and grooms do not actually know the musician performing in the ceremony.

Left: Here I used a shallow depth of field and got down on the ground (at an aperture of ƒ1.8) to focus on the petals in the foreground while the bride and groom are out of focus. The success of this type of shot depends on the bokeh of your lens (the way in which it produces out-of-focus areas in a shot).

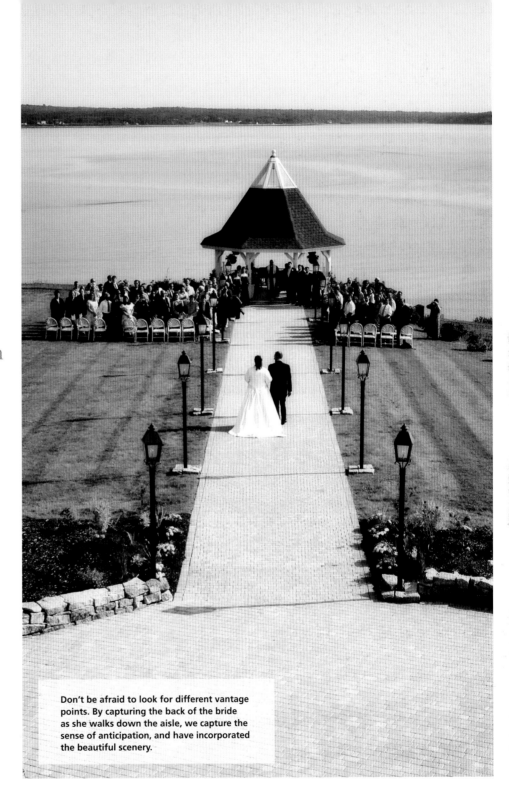

Don't be afraid to look for different vantage points. By capturing the back of the bride as she walks down the aisle, we capture the sense of anticipation, and have incorporated the beautiful scenery.

There are so many different types of ceremonies—from civil to religious, and ceremonies that combine elements of each or elements of different religions. In addition, couples often try to put their own personal stamp on the ceremony with special readings, traditions, and music. There are also many different types of locations which, as discussed earlier (see page 40), can be very differently lit. I always try to have a clear understanding of the details of the ceremony itself—the length, the schedule, special events, who is going to be involved, and where they are going to stand—in addition to the details of the ceremony location and lighting.

I usually arrive about ten minutes before the bride, and I take this opportunity to take some test exposures, to photograph the interaction of the guests, and to photograph some of the details

of the ceremony (flowers, candles, and other decorations). There are a few photographs that I try to take at every ceremony—the main one is the processional. I usually stand at the front of the aisle so that I can photograph the bride coming up the aisle and swivel quickly and photograph the groom's face as she advances. If I have a second photographer with me, I position him at the back of the ceremony so that he can photograph the back of the bride's dress with everyone swiveling to look at her.

After the processional, I head to the back of the location. If there is a balcony and I have a second photographer, one of us goes up in the balcony and the other roams from side to side in the back of the church, remaining as unobtrusive as possible. We shoot with long lenses, and if the ceremony is inside we photograph in aperture priority, wide open, so that we can take advantage of

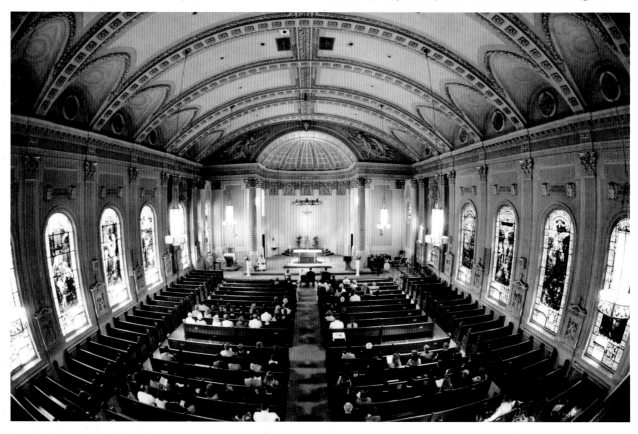

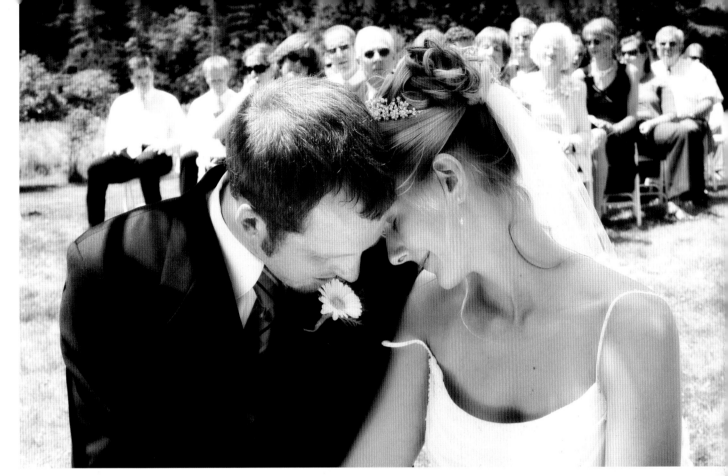

the available light without using flash. At some point during the ceremony I try to take a fisheye shot of the ceremony, often from a balcony if there is one, so that there will be a photographic record of the ambience.

At some point I try to take a fisheye shot of the ceremony

Different marriage officiants ask the bride and groom to kiss at different times—this is an important photograph that most brides and grooms are going to want to see, so I like to have a general idea of when it is going to happen before the ceremony starts. I try to position myself straight down the aisle from them (unless the officiant has chosen to stand in front of the couple) and photograph them so that I can see both of their faces as they go in for the kiss. They will inevitably turn and look at the guests after the first kiss, and often this will be one of the best expressions I will see from the bride and groom all day. Also, by standing down the aisle from them, I am in a good position to capture them as they turn and leave.

Above: It's not always feasible, but during some outdoor ceremonies it is possible to shoot from in front of the couple.

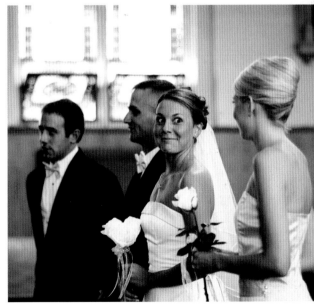

Right: By getting to the side of the couple during a ceremony you will be able to see some of the fun and touching glances between the bride and groom and the couple and their attendants.

\mathcal{P}ost Ceremony

The time immediately following the ceremony is one of my favorite times to photograph during the wedding day. The bride and groom (and their family and friends!) are often very emotional. Often the bride and groom will take a few moments by themselves—I like to capture these scenes from afar: a tender touch on the cheek, a tearful hug, a series of exhilarated smiles and laughs.

The bride and groom often have specific plans for what they are going to do immediately after the ceremony is over. Some have receiving lines, some leave immediately to start the formal photographs, and some stage interesting exits from the ceremony site. I like to know before the wedding day if the bride and groom are going to do a receiving line, because often they will not budget enough time for it. I have seen some receiving lines take up to an hour, so I like to talk to the bride and groom beforehand to make sure that we have enough time to take all the photographs that they want.

If the bride and groom are doing a receiving line, this is a fantastic opportunity to photograph candids of the bride and groom being congratulated by individual guests. You can capture some really touching photographs—tears and laughs, handshakes and hugs. It is a good time to catch the bride and groom with some great expressions as they greet all their friends and family. Often, this is the first time that they have seen many of their guests, and this can be wonderful for heartfelt reunions.

Sometimes the bride and groom will stage an exit, coming out of the church/building while the guests throw flower petals or rice or blow bubbles. These are fun photographs to take, but make sure to stake out your spot in front because guests will often press forward as the bride and groom make their exit.

At the end of the ceremony you have everyone's attention

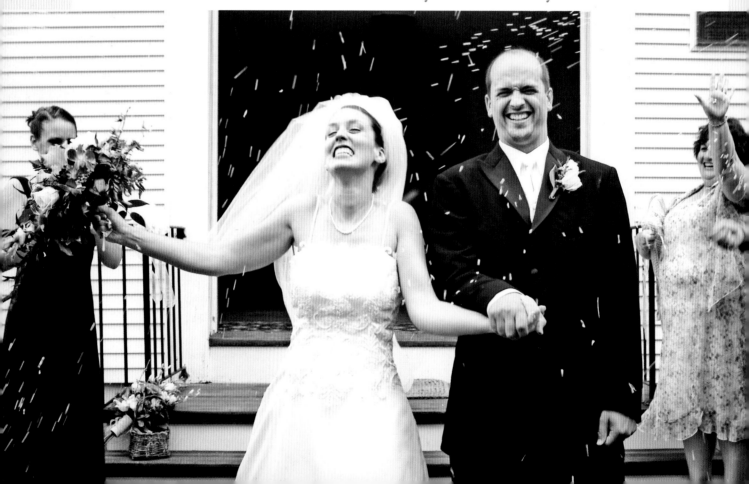

If the bride and groom want a photograph that includes all of their guests, this is often a great time to do it. Once the reception starts, it is difficult to get everyone in the same place at the same time. At the end of the ceremony, though, you have everyone's attention. I either try to get above the crowd and shoot down on them so that I can see everyone's face, or I try to position them on steps to achieve the same effect. I position the bride and groom in the front, and I usually have them kiss or walk toward me while the crowd cheers.

Sometimes the bride and groom have hired interesting transportation for the day—horse-drawn carriages, trolleys, antique cars, or limos. After the ceremony is usually a good time to incorporate the vehicle into the photographs because you have both the bride and groom and the bridal party as backdrops and/or to interact in the shots.

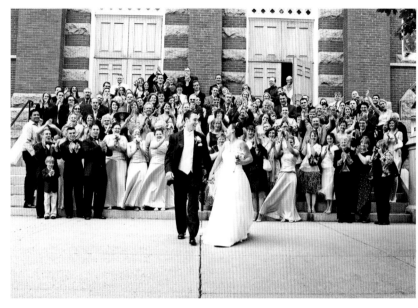

Above: I was able to place the guests on the steps of the church while the couple walked away to the limo. You can even see the priest peeking out of the door!

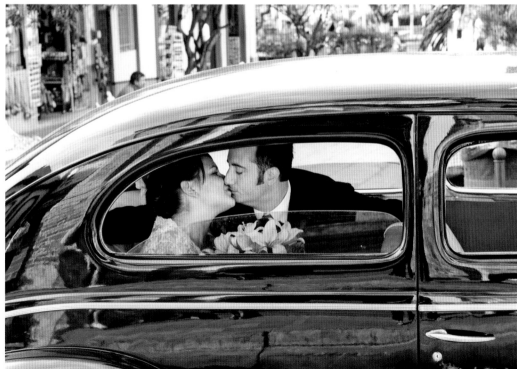

Far left: You get some great expressions as rice or confetti is thrown. I used a shutter speed of 1/125 here, fast enough to stop the movement of the couple, but slow enough to allow me to capture movement in the rice.

Left: Be ready to capture a display of affection through the windows of the getaway car! It allows you to incorporate the car easily, too.

POST CEREMONY

I try to have a few different locations scoped out ahead of time—the first for the family shots, and the rest for the bridal party and couple location shots. For the family formals I try to find a comfortable, accessible location with good light. I want to find a spot out of the direct sun (especially if it is in the middle of the day in the summer) and that is accessible for people with canes and wheelchairs. I will always choose a location that will be good for expressions rather than for capturing the view. I always speak to the bride and groom beforehand about this, but for me it is more important to capture family formals where the family members are not squinting or sweating profusely in the direct sunlight. Most of the time the bride and groom will agree (especially since we will go on to use the location with views during the photographs of the couple).

However, if the bride and the groom really have their hearts set on taking the formals in a certain location, I will photograph them where they want them done but will try to do a second set of the immediate family in a location with better light. If the location that the bride and groom have chosen has harsh lighting or shadows, I may need to add a reflector or some fill flash to the formals.

I always look for good light first

I also try to have some locations picked out for the bride and groom and bridal party photographs. When choosing locations, I am thinking about how much time the bride and groom have given me for the photographs and the transportation that is available. Sometimes, with ample time available, the bride and groom may want to travel to a number of different locations. This is the scenario that I like best because it gives me an opportunity to create amazing photographs at a number of different locations.

If we don't have a lot of time or access to transportation, I try to choose a number of interesting locations that are close by. I always look for good light first—sometimes you can make amazing portraits on the side of a dumpster, if you have the right kind of light! If there is a beautiful view, I also try to incorporate that into at least some of my bride and groom photographs. For the most part, though, I try to give them variety, so I may pick a dozen or so locations to try. We may not have time to get to them all, but at least I will have enough ideas to keep me going for as long as they give me for the photographs.

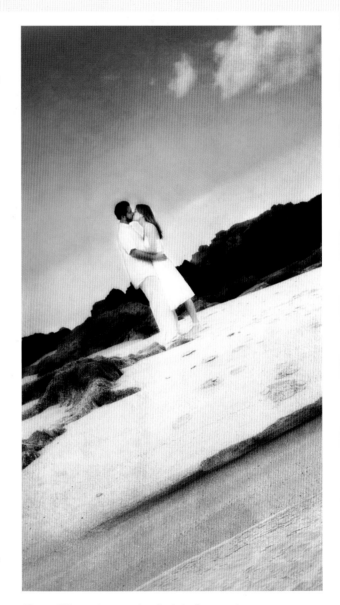

Above: This couple wanted to do their photographs at the beach—to avoid the harsh light, I got them ready to go at seven in the morning, just as the sun was rising over the mountains.

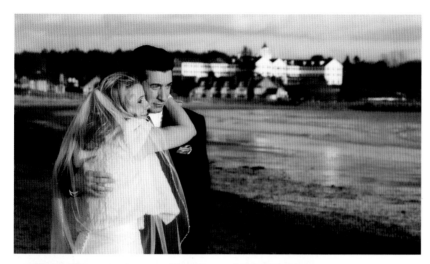

Left: This couple also wanted to incorporate the beach into their photographs. To avoid the harsh light, we chose to photograph them as the sun was going down.

Below: This nice, shaded area was perfect for this couple. The arch added a bit of visual interest to the photograph.

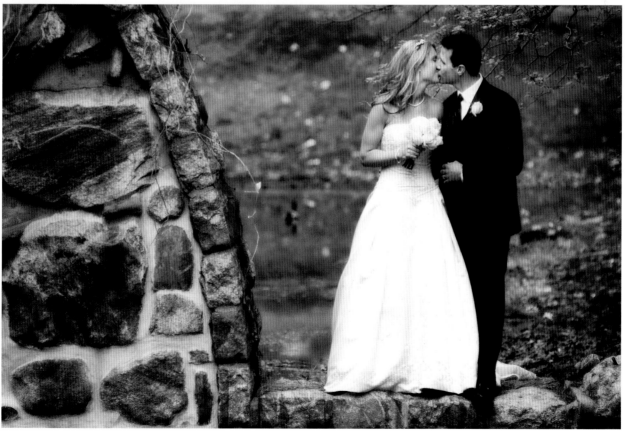

Family Formals

Some photographers do their family formals off a list supplied by the bride and groom, and this works really well for them. We do not photograph formals from a list; rather, we do a set number and combination of family photographs that usually covers everything the bride wants. We do it this way because it minimizes the amount of time that we need to do the photographs. Essentially, what we do is start with a big photograph and then ask people to step out of the photograph so that we break down to smaller groups. We make sure that we know whether there are any divorces in the family and whether they are amicable or not as this may affect how we position people and how many groupings we choose to do. However, with a typical family we will do the following:

We make sure that we know whether there are any divorces in the family

a Bride and Groom and Bride's Extended Family. We position the bride and groom in the center of the photograph with parents and siblings next to the bride and groom. We ask everyone else to fill in and then shift people around if we can't see their faces or if they position themselves unevenly or awkwardly.

b Bride and Groom and Bride's Immediate Family. We simply ask the extended family to step out of the previous shot. I already have the immediate family in position, so as soon as everyone is out of the way I am ready for the next shot.

c Bride and Groom and Bride's Parents. Ask the siblings to step out of the previous shot.

d Bride and Bride's Parents. Ask the Groom to step out of the shot.

e Bride and Bride's Mom. Ask Dad to step out of the shot.

f Bride and Bride's Dad. Ask Mom to step out and Dad to step back in.

g Bride and Siblings. Ask the siblings to step in again.

h Bride and Grandparents. If the grandparents are infirm or mobility impaired, we may do this shot first so that the grandparents can go and sit down.

If there are godparents or special relatives that we know about, we will do those next. These photographs go very quickly, and after we have done this series we will ask the bride and groom if there are any that we missed. Then, we will dismiss the bride's side of the family (unless they are in the bridal party) and move on to the groom's side of the family. We repeat the same list. If, for example, the bride's parents are divorced, we may do one series with the bride's father's side and one with the bride's mother's side. This depends on the relationship or wishes of the bride and groom, so I make sure that I find out what they want to do well ahead of time.

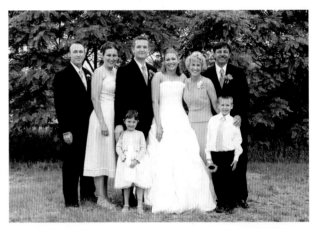

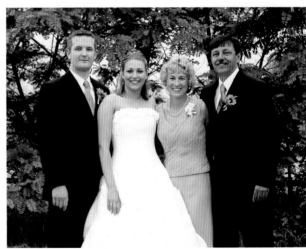

Top left: Starting with the extended family, I place the parents together on one side of the couple or split them up with one on either side of the couple. That sets me up for the next photograph.

Right: Here is a shot of the couple with the groom's parents. They are divorced, but the groom still wanted a photograph with both together. In this case, I have separated them on either side of the couple.

Bottom left: After setting up the previous shot, all I have to do for this photograph is to ask the sister and her family to step out.

Below: With both of the groom's parents happily remarried for years, it was possible for us to do a photograph of his parents with their new spouses. Be sure to communicate with the bride and groom before the wedding if there are divorces that you need to contend with.

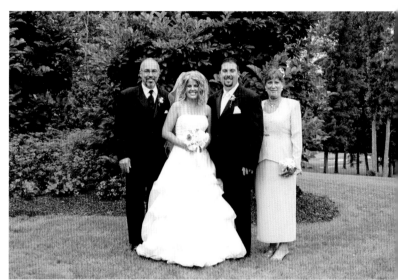

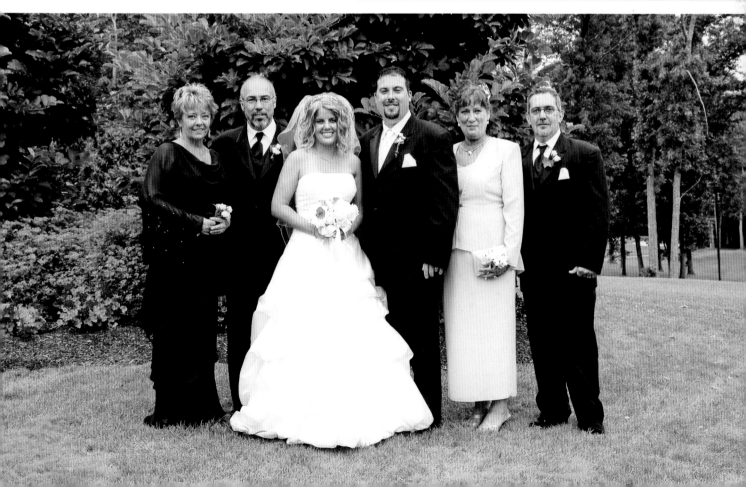

Bridal Party—Stationary Portraits

I have never run across a bridal party that is excited to take photographs. Most of them have been to weddings where they do a lot of standing around and waiting after the wedding, and usually after the ceremony they are settling themselves in for the long haul of formal photographs with grim determination. I try to change all that in the first few minutes of working with a bridal party. I want to keep everyone happy while capturing meaningful photographs of the people most important to the bride and groom.

We want our couples to feel that they have stepped out of the pages of a magazine

First, I start with a very simple standard photograph of the bridal party with the bride and groom in the middle and then the men on one side and the women on the other. This is the shot that they are expecting. I don't do a lot of setup for this shot—if I have a group with radically different heights I may shuffle people around, but for the most part I just line them up and snap a few photographs, spending no more than three minutes on this shot.

I will usually split them up into two groups—the bridesmaids and the groomsmen. I will give one of them a break while I work with the other group. Once again, I try not to take more than five minutes with each group so that there is a minimum of standing around. If we are pressed for time, I will have my second photographer (if I have one) take the men while I photograph the women. Once again, we will do a quick shot of them formally lined up. Then, we try to do something more creative. The photographs of the bridesmaids usually involve less movement and more hugging since they are often in high heels and constricting dresses. With the men (if we haven't photographed them as a group prior to the ceremony), we find that they want to look cool, so we have them walk, wear their sunglasses, or try a shot with the groom in the foreground and the groomsmen fading out of focus behind him.

While we have them separated into groups, we often take a quick shot of the bride with each of her bridesmaids and the groom with each of his groomsmen. This is typically a very easy task with the bridesmaids because they hug each other and press their cheeks together while they look at the camera. The men tend to be a bit

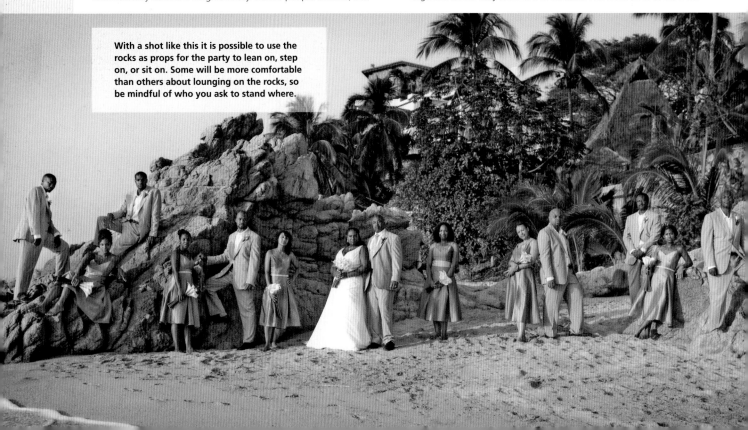

With a shot like this it is possible to use the rocks as props for the party to lean on, step on, or sit on. Some will be more comfortable than others about lounging on the rocks, so be mindful of who you ask to stand where.

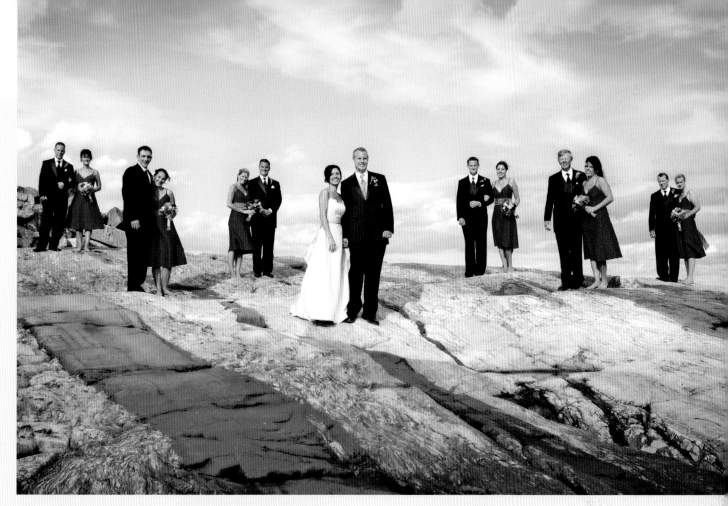

Above: If you have nothing to prop your bridal party on, it is still possible to create an interesting photograph by separating them into couples and staggering them.

Right: This playground which was next to the ceremony site provided us with a great opportunity to stagger the bridal party in a fun shot.

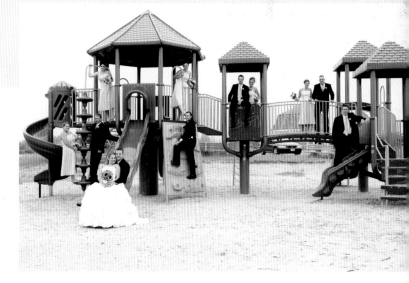

stiffer—we often tell them to go up one at a time and congratulate the groom, then look at the camera. Since we don't tell them exactly what to do, we get different, often more heartfelt shots with the groomsmen. Some of the men will hug the groom, some will shake his hand. But with each, some real emotion will occur within the formal moment.

Time and location permitting, we also try to take a location shot of the bridal party. We want our couples and their attendants to feel that they have stepped from the pages of a magazine, and we try to arrange our photographs accordingly. To do this, we try to set up our last bridal party photograph in a way that highlights the location to its best effect.

Bridal Party—Interaction Portraits

Next, we try to move the bridal party around. No matter how wonderful you are at telling jokes or loosening people up, there are simply some people that will not smile for the camera in a formal photograph. Once you get them to move, you can change that. You give them something to do other than look at the camera, and this will often distract them for long enough to give you the opportunity to get a great expression. It also gives the bridal party something different to do, and gives you the opportunity to make great portraits of the bride and groom interacting with their attendants.

Most of the time the members of the bridal party are not expecting to move around, so it can occasionally take some coaxing on my part. I line them up and tell them to make sure they can stick their elbows out and not hit anyone (make sure you have them give each other enough space, or they will overlap and step on each other). If you have a group that gets along well, you can also have them link arms. The movement that we do depends on the personality of the group as a whole—if they are mobility impaired for some reason (whether because of the heels the bridesmaids are wearing or because of someone's injury) I just have them walk

I allow the spirit of the group to dictate what we do

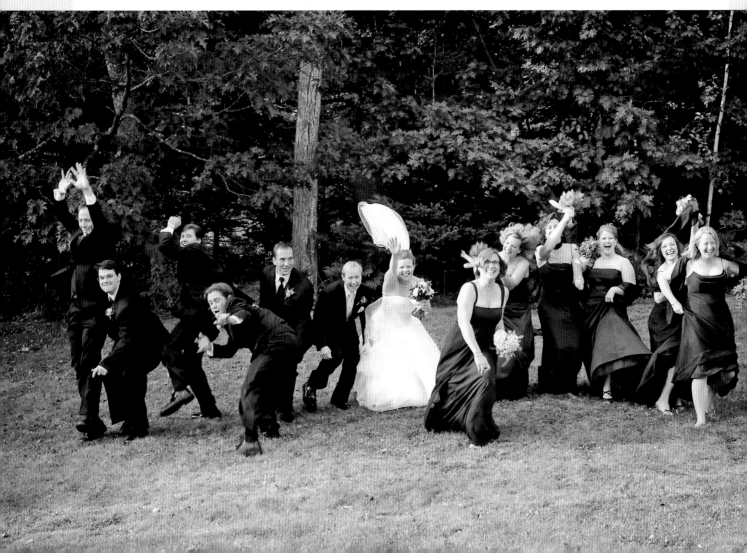

Top right: If you have kids that are afraid to look at the camera, sometimes the walking photograph can be your best option. No one is actually looking at the camera, and sometimes the kids don't even know that you are snapping away.

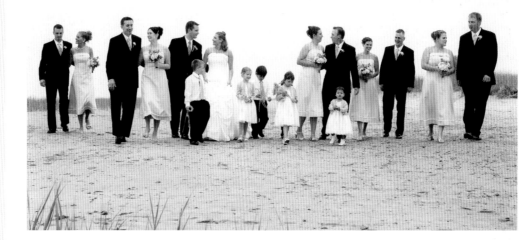

Bottom right: The walking shot is a great way to capture the bridal party in direct sunlight without a lot of squinting—because they aren't looking right at you, it will be easier on their eyes.

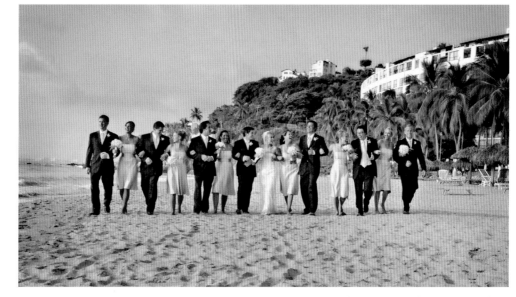

Left: If you have a really adventurous group, they may want to jump in the air or run!

toward the camera. I tell them that the only rule is that they can't look at the camera—they have to look at each other while they are walking and talk about what they are going to do at the reception. Make sure you give yourself some space—the first few steps they take toward you are usually stiff. After a few feet, though, someone will say something funny, or they'll start laughing, and you will get great expressions.

If I have a more energetic group, I have them skip, and sometimes I have them jump. I allow the spirit of the group to dictate what we do and how long we spend on the interaction portraits of the bridal party. Some of the more fun groups will even start suggesting things themselves! In virtually every wedding that I have photographed, the bride and groom will choose the interaction photograph for their album rather than the typical bridal party shot that we took first.

Bride and Groom Alone

Most brides have no idea how to stand if they are standing alone. Many just stand square to the camera, stiffly upright, arms tight against their bodies. This is not a good look for anyone, so I give the bride some direction. I turn her slightly, have her put her weight on her back foot and point her front toe toward the camera. Then I have her push her hips back slightly (away from me, so that she looks like she is leaning toward the camera a bit). I do a full-length and half-length shot. If she is wearing a body-hugging dress to show off curves, then I may position her more square to the camera to show these off, but I still make sure that her weight is positioned on the back foot and that there is space between her arms and her body (show her how you want her to hold her flowers).

Left: Most grooms are incredibly stiff at first. You can get them to loosen up a bit simply by asking them to put their hands in their pockets.

Above: For most brides you will need to have them turn to make them look slimmer. This dress emphasized the bride's slim yet curvy figure, so I photographed her front on to emphasize the curves.

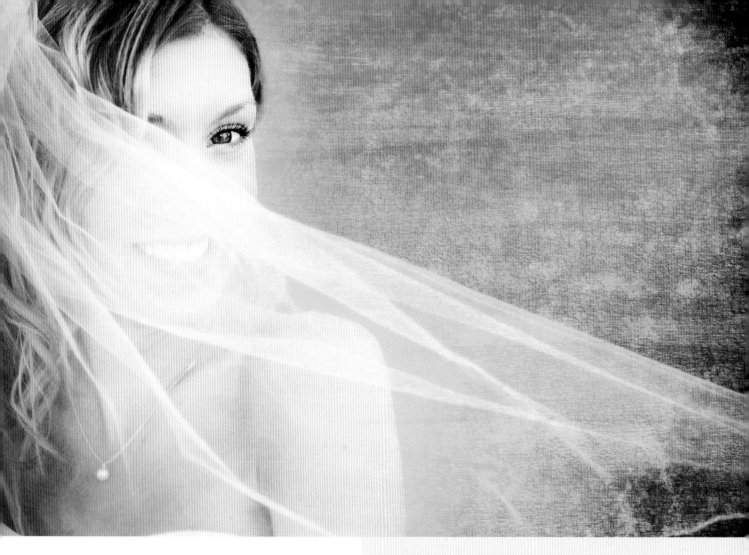

I also try to shoot the bride from above. If there is anything that I can stand on, I will do so, but most of the time I simply have the bride crouch (I always ask if she has good knees first!). The bride loosens up and usually laughs because she feels silly—this gives her a great expression and consequently this is the photograph that the bride usually likes best of herself.

The bride loosens up and usually laughs because she feels silly

We will do one or two full-length shots of the groom—we have him turn his body slightly and put his hands in his pockets (usually this will get the groom to loosen up). Most of our shots of the groom will be half-length or head-and-shoulder shots, though, as these look best in the album opposite the crouching shot of the bride.

Above: In this photograph I used a very shallow depth of field (at an aperture of ƒ1.4 on my 85 mm) to keep the bride's eye, which is the focal point of this composition, tack-sharp while the rest recedes out of focus.

Even if we are photographing them alone, we are always looking at how the photographs will look together. If we are photographing the bride and groom against an interesting wall, we may compose the photograph of the groom with him on the far right and the photograph of the bride with her on the far left. That way, they present a dynamic set when viewed together. We also try to present some different photographs of them as well—perhaps a photograph of the bride where we have only caught half of the face or a photograph of the bride where only her eye is in sharp focus and the rest of her face is obscured by her veil.

Bride and Groom—Standard Portraits

Most of our couples come to us wanting something a little different—elegant portraiture that is different and not just a series of the two of them looking at the camera. However, I am mindful that although these may not be the shots that the couple wants, these may be the type of shots that their parents and grandparents want. In addition, even though we have just done some fun bridal party shots, the bride and the groom may stiffen up when it is just the two of them and the camera. Some people want a little bit of direction in the beginning, and will quickly loosen up once you start working with them. So, we take a very quick series of the bride and groom in three poses and then we ask the bride and groom if they want us to photograph the bride alone or the groom alone or both.

For these photographs we usually use a shallow depth of field

For the first pose, we position the bride and groom in a V to the camera. Usually the groom has his arm around the bride. For the first pose they are usually quite stiff, and we may need to tell them to press their cheeks together (if their different heights allow for it without looking awkward) or to snuggle into one another. This goes right into the second pose, where we have them hug, chest to chest, with both of their faces turned in our direction. For the third pose, we have the bride flip around so that her back is against his chest and his arms are around her. This works well when the groom is significantly taller than the bride but can be quite awkward if they are of the same height or if the bride is taller, so we don't always do this photograph.

For these photographs we usually use a shallow depth of field, but not the maximum on our lenses. We are usually at ƒ4 to 5.6 because we've found that not everyone appreciates the shallow depth of field that we use for the rest of the day, and these shots should have the broadest possible appeal. We do a combination of full-length, three-quarter length and head-and-shoulder shots of each pose, and try to spend no more than five minutes on them.

Right: If there is a flowering bush or tree around, you might use it for a background for a cropped couple's portrait. This bride loved bright colors, so this was an ideal place to photograph them.

Below: The bridge was a central feature in this park, so I have just hinted at it in this standard photograph of the bride and groom. If it is a very windy day, you can position the bride so that the veil blows behind them, but wait until you've had chance to capture some great candids of the veil blowing in their faces!

Right: If the bride and groom are having a destination wedding, you might consider choosing a location for photographs that will allow you to highlight the destination wedding location. Of course, there are more subtle ways to incorporate it than in this photograph, but Las Vegas is not a subtle location!

Bride and Groom—Original Portraits

Once we have the standard photographs out of the way, we move to the portraits of the bride and groom that show them as a part of their environment. Although the composition may be the same for a lot of couples, we try to incorporate the elements that make their wedding unique. It might be their beautiful antique car or the trolley they drive away in, the palm trees waving in the breeze or the snow-covered mountains in the distance, the city skyline in the background, or the wide expanse of white sand and blue water—whatever scenery makes the location that they have chosen interesting and different.

We try to incorporate the elements that make their wedding unique

For this series of photographs the bride and groom are rarely in the center of the frame—they are usually on one side of the photograph or the other. They are often interacting with one another—hugging or kissing—rather than looking directly at the camera. They may have their eyes closed or be staring out of the frame of the photograph. When composing these photographs, I can save myself a lot of time in post-processing by being mindful of the distracting elements in the photograph—signs, power lines, trees growing out of the couple's heads, etc. I try to compose my photographs in camera rather than rely on extensive post-processing to cobble a photograph out of a badly composed shot.

I photograph most of these portraits with existing light, although I may find it necessary to use my video light or a bit of fill flash to pull up the shadows on the faces of the bride and groom it they are either backlit or in a very dark area. I photograph most of these portraits with a wide aperture ($f1.4$ to $f2.8$) and with a short lens (usually my 17–55 mm, $f2.8$ or a prime lens in that focal range). I shoot wide open to give myself a narrow depth of field and to separate the bride and groom from the background. Very rarely do I want the entire scene to be in focus; rather, I want the bride and groom to be sharply in focus and the foreground and the background to be receding out of focus. If there is a beautiful sky (or I want to add some variety to background shots), I may photograph the bride and groom from the ground. Sometimes a palm tree blowing above the couple or a fantastic blue sky can provide a great backdrop.

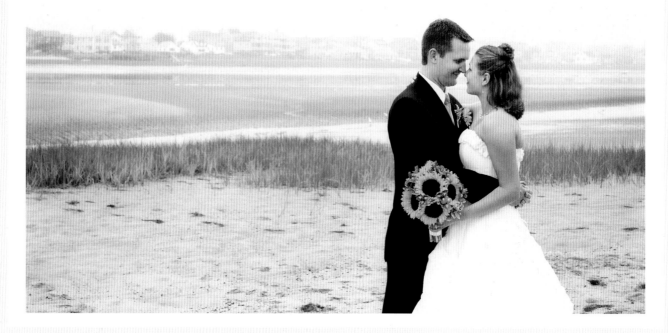

Opposite page: I wanted to make this photograph about the setting as much as the couple—the mist, the houses dotting the shoreline, and the dune grass are important elements in this photograph.

Below: This couple had a beautiful New England coastal wedding. I wanted to highlight the fact that the seersucker pants and sash on the bride's dress matched the beautiful blue sky, so I shot this photograph from below with a fisheye.

Right: This couple wanted some "downtown" photographs. Brick walls can really add an urban touch to photographs as well as providing some visual interest.

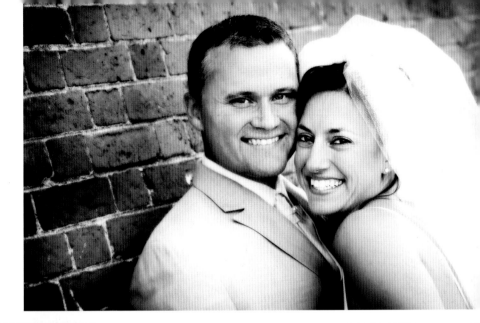

Bride and Groom—Interaction Portraits: Movement

Once I have photographed the bride and groom in their environment, I try to get photographs of them interacting with one another. Some of my couples are naturals—they are constantly teasing and laughing with one another and all I have to do is stand back and observe. For these couples, telling them to take a walk hand-in-hand on the beach may be all the prompting they need—they will naturally stop and kiss or spin each other around or make each other laugh.

They will naturally stop and kiss or spin each other around or make each other laugh

Other couples require some prompting to interact with one another—for these couples I provide some direction. I tell them to stop and kiss at a certain location on their walk. I have them jump in the air or skip or run or twirl each other around—this almost always makes them smile at first and then break out in infectious laughter. Some of my more reserved couples may be reluctant at first—I tell them that they may feel really stupid skipping down the lane, but that it will look fantastic in-camera. And it almost always does—they loosen up, they laugh, they have fun with one another. Sometimes I only need to give them one directive and they take it from there. During these photographs I am usually looking for a series of three or four photographs in a matter of seconds—interactive portraits for the album that will be presented as a series.

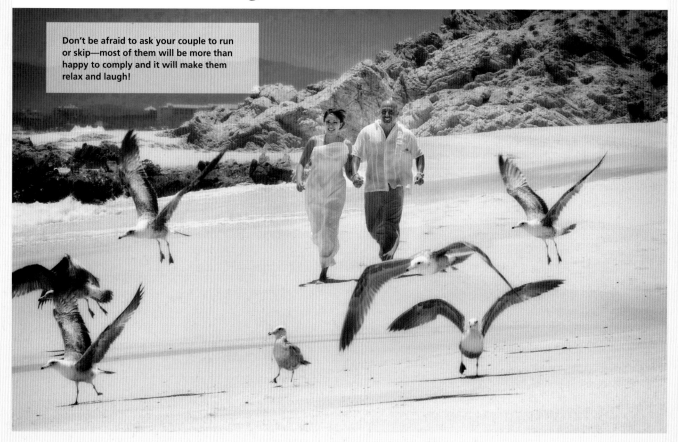

Don't be afraid to ask your couple to run or skip—most of them will be more than happy to comply and it will make them relax and laugh!

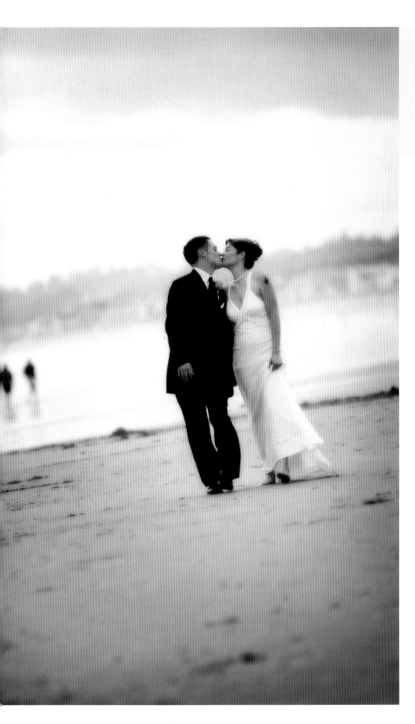

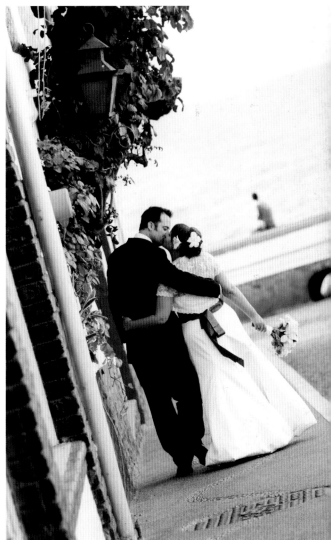

Left: If you ask your couple to walk and talk on the beach while you stand far away with a long lens, most of them will be quite affectionate with one another as they go.

Below: I love this alley with the ocean in the background and wanted to incorporate it, but the lighting was all wrong. Rather than use fill flash, I simply had them turn around and walk away from me.

*B*ride and Groom—Interaction Portraits: Cuddling

I also like to capture some photographs of the couple cuddling and nuzzling one another. They have usually done a lot of kissing by this point in the portrait session, but I like to capture them cuddling without kissing as this can often produce a more intimate, emotional photograph. Usually I have them sit somewhere, the bride sitting against the groom, with the eyes closed. I have them whisper to each other and cuddle—they will usually have some great expressions as they share their first "alone" time after the wedding.

They have usually loosened up within the first ten seconds and you get some really great expressions

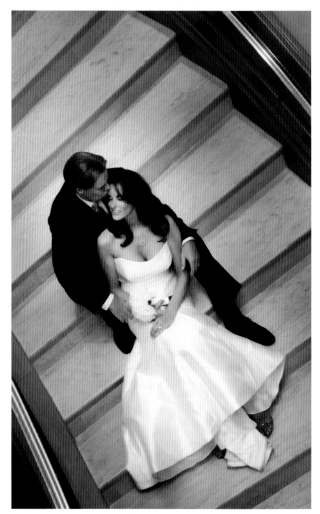

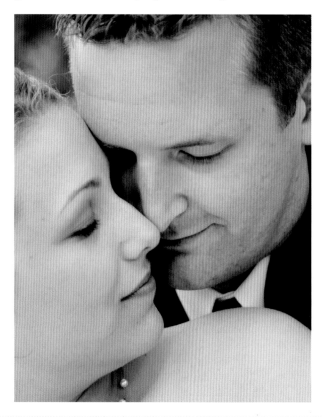

Left: A shallow depth of field helps to draw the attention to the couple's eyes and lips while the background is thrown out of focus.

Above: Balconies are great because it will give you the opportunity to give the couple a little bit of "privacy" for their cuddling shot while capturing them at a different angle.

Opposite page: You can create a beautiful portrait by focusing on the eyes of the bride (or groom!) while their partner is cuddling them.

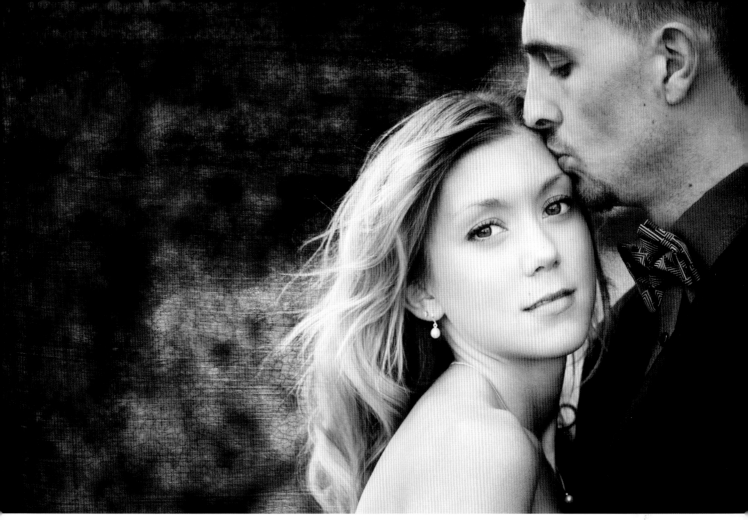

If the couple is having difficulty looking "intimate" enough, I will give some direction. I sit the groom on the ground or on a step and position the bride in-between his legs and have her lean against his chest. I have the bride close her eyes, then I tell the groom to kiss her temple and then slowly kiss his way down her face and neck to her shoulder. This works wonders—they have usually loosened up within the first ten seconds and you get some really great expressions. Sometimes they laugh and smile, other times they smolder—either way, I get some great interaction portraits.

I tend to focus in close on the bride and groom, often cropping out portions of the faces of one or both of them. I use a long lens so that I can photograph them from afar, giving them a bit of "privacy." The long lens, shot on a wide aperture, will give me a very shallow depth of field, allowing me to draw the focus to the couple.

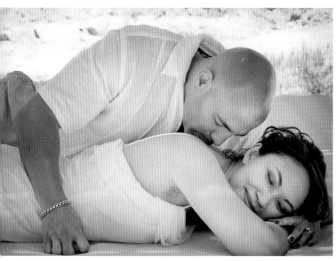

Left: By getting your couple to lie down, you can create an intimate portrait in even the most crowded setting.

Bride and Groom—Portraits with Color

One of the first things that I look for when I am scoping out locations for bride and groom portraits is a background that is an interesting color. Even the most drab locations sometimes have an area that is painted a bright, different color or a colorful mural. These will be the backdrops for some of my favorite photographs. A brightly colored background can add a bit of intensity and visual interest to your photographs, whatever the location. Many of my couples have remarked that the bright background gave their photographs the look of an exotic location, even if they were just taken in their hotel or in an urban setting.

Don't be afraid of a wall or mural that is cracked or dirty or has peeling paint—a lot of my photographs against bright walls tend to be dirty colorful walls. I find that the dirt and peeling paint only serve to add an interesting element to these photographs. Like most of my other photographs, I tend to shoot these portraits with a shallow depth of field, so the dirt and peeling paint are often thrown out of focus, so may appear simply as splotches in the background. I live in

an area of the world where bright colors (other than barn red) are few and far between—however, even the smallest patch of color will do! These are not often full-length portraits (although I love it when I have that kind of flexibility with a large colorful space) and most often I find myself shooting half-length shots with my long zoom on ƒ2.8 or my 85mm on ƒ1.4 or ƒ1.8.

Although more brides are choosing gowns in colors other than white, white gowns with black tuxes or suits still remain the norm. Brightly colored backgrounds can provide a stark contrast to the black and white attire of the couple. Even the veil is almost always white, and it can make for a visually appealing photograph to have the bride play with her veil or let it blow in front of a brightly colored backdrop.

A brightly colored background can add a bit of intensity and visual interest to your photographs

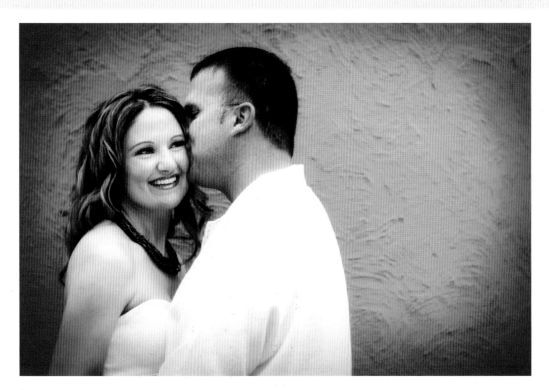

Left: This was a small swatch of color, but I loved it, so I zoomed in close on the couple to be able to incorporate it.

Right: Everything about this scene— the cacti, the ocean, the sky, and the beautiful wall— screams "destination wedding." I wanted to incorporate the color in a way that would also highlight the environment.

Far right: Without the colorful wall, this is just an average photograph. The color makes it much more dynamic!

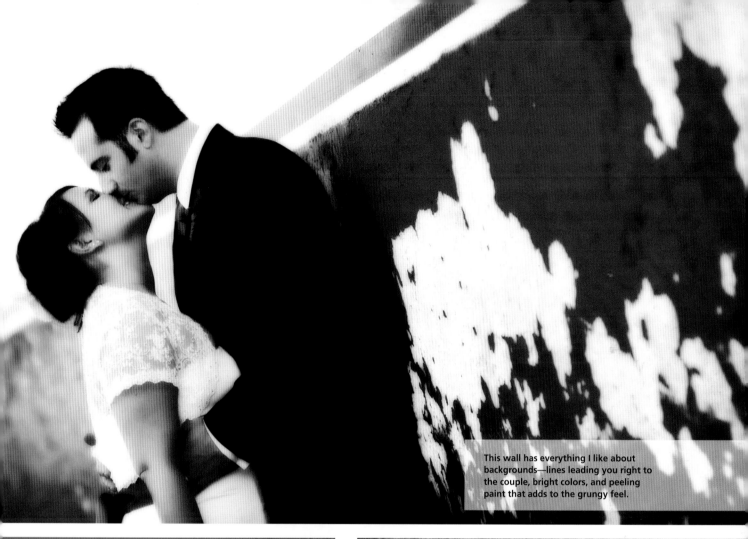

This wall has everything I like about backgrounds—lines leading you right to the couple, bright colors, and peeling paint that adds to the grungy feel.

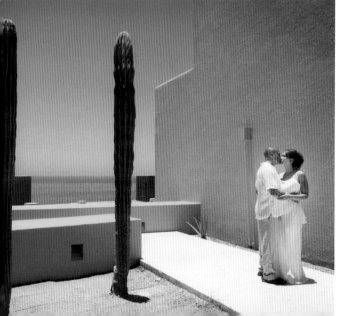

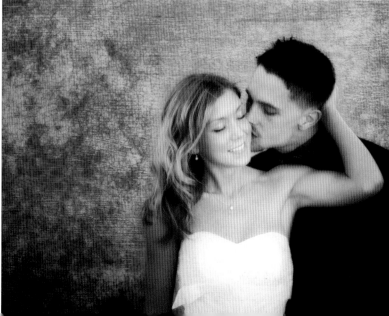

Bride and Groom—Urban

After I have looked for bright colors, I will look for other interesting locations—staircases, windows, brick walls, or alleys with good light. Any location is fair game—some of my most interesting photographs have been taken against backdrops of graffiti or abandoned buildings. The urban environment provides a fantastic challenge—urban environments are often quite crowded, and you will have to make the decision as to whether you are going to isolate your couple from the crowd or whether you will somehow incorporate strangers into the photograph. I tend to go with the former, although I have seen some incredible photographs with onlookers adding to the strength of the composition.

The urban environment provides a fantastic challenge

In the urban environment it is often quite easy to find stairs or balconies, giving you the opportunity to shoot down on the couple. I also like to look for buildings that give you the opportunity to shoot across into another building. Old, converted mills and factories are wonderful for this—usually constructed in brick, the windows are often large and arched. I like to position the bride and groom in one window while I shoot across the street from another building, balcony, or even the top of my car—anything that can give me some height to get me on the same level as the bride and groom.

I also look for interesting doorways, signs, and vehicles when we are in an urban environment. Usually there is no shortage of interesting props or backgrounds in the city, especially if you have the time to walk around. Different places have different rules about photographs, but train and subway stations can make for interesting backdrops—I like to use train tracks to provide interesting, leading lines to the couple.

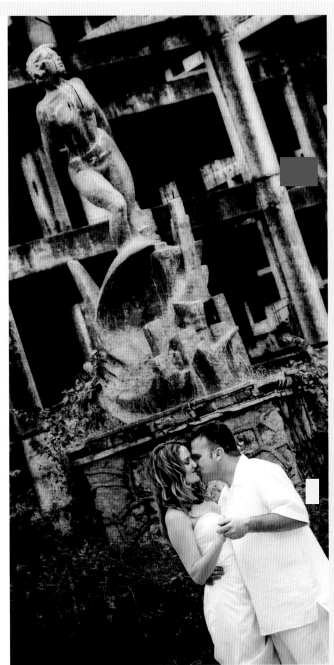

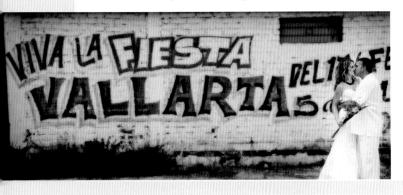

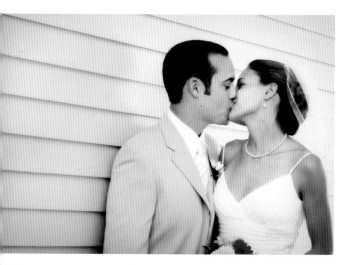

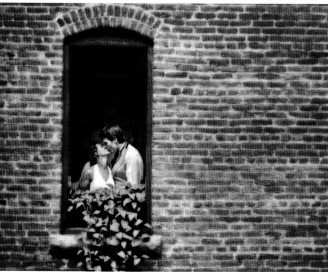

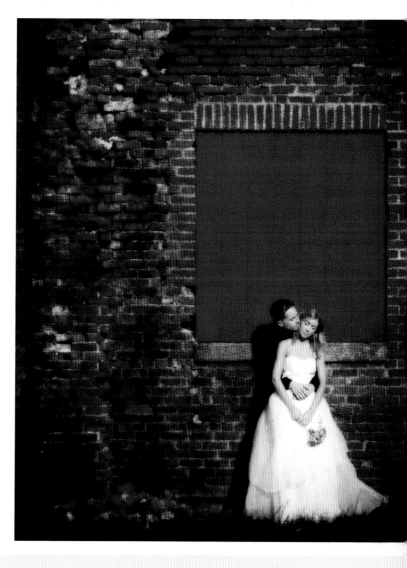

Opposite page left: Graffiti can be a great element in the photograph— especially when it helps to add color and give you a sense of place!

Opposite page right: This photograph was taken in front of an abandoned hotel. I post-processed it to emphasize the ruins and warm the shadows.

Top left: The lines lead right to the couple and the color helps the couple stand out in this photograph.

Above left: I stood in one building and had my couple stand in another, then I photographed through a window to incorporate this gorgeous window.

Above right: The crumbling bricks and color in this scene add an interesting urban element to this photograph. I had them close their eyes because we were in the harsh midday sun.

Bride and Groom—Country/Forest

If I am photographing a bride and groom in the country, I will first look for interesting buildings or vehicles that can serve as backdrops. Barns make great backdrops and many older farms have fantastic older vehicles such as tractors, cars, or trucks. I also look for fences, as these can serve as beautiful props as well. **Country wedding venues can afford fantastic opportunities for foliage photographs—whether decked out in the bright green of spring or the bright reds and yellows of fall, the fields and forests themselves serve as wonderful backgrounds for photographs.**

For destination weddings, the vegetation can often serve to let the viewer know that the wedding is at an exotic location. In tropical locations, I like to take the couple into the surrounding forest in addition to the beach in order to get some gorgeous shots with the trees and leaves that are distinctive to that particular area of the world.

I also like to use flowers as backgrounds for photographs with the bride and groom. Sometimes I have the flowers in focus in the foreground and have the bride and groom out of focus in the background. Like brightly colored walls, flowers can turn an ordinary photograph into something special, serving as a visual reminder of the location of the wedding.

Country wedding venues can afford fantastic opportunities for foliage photographs

Above: This couple was married in the rainforest of Central America, so I wanted to include the local foliage in this photograph to give it a sense of place.

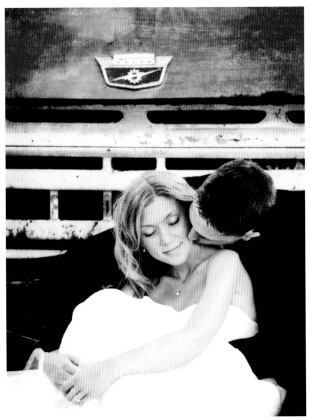

Opposite page right: We photographed this couple on an old farm in Maine—this old truck was rusting in the yard, so I just had to use it!

Right: This couple was married on a ranch in Aspen, Colorado. I incorporated the split-rail fence in the photograph to give it the feel of a western ranch.

Below: This couple was married in the fall with blazing foliage colors. They were positioned so that the subtle path leads directly to them, leading your eye in what is otherwise a bright, distracting background.

Bride and Groom—Beach

The beach is one of my favorite places to photograph the bride and groom. Most of the time you have tons of space to work with, and even if the beach is crowded it is quite easy to isolate the bride and groom in a certain location, especially if you are photographing the water behind them. I also find that everyone loosens up when they are on a beach—I try to convince them to take off their shoes and run and dance in the sand. Even the bride who is worried about getting her dress dirty will usually venture to the water's edge and dip her toes in.

With most white or yellow sand beaches, it is possible to have the bride and groom sit on the sand without getting the dress or suit dirty. Most of the time, the sand brushes right off. Try it yourself first, though! I like to have the bride and groom sit on the beach together—often with the bride sitting in between the groom's legs and leaning back against his chest—and cuddle and hug.

Of course, the beach is also a great place to do interaction portraits with the bride and groom running in the sand, playing at the water's edge, and walking together. If we are photographing the bride and groom at the beach, I will always photograph them walking on the beach hand in hand, composing the photograph with the bride and groom on the side with the water leading up to them.

The beach is a great place to do interaction portraits with the bride and groom running in the sand

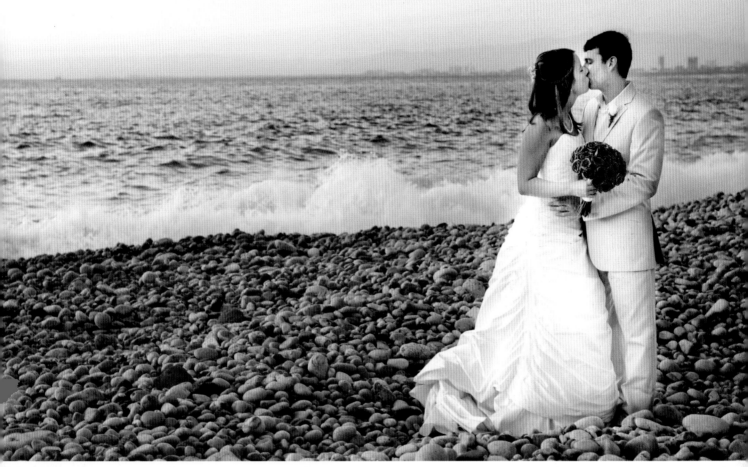

Above: If the couple is married on a rock beach, it will be difficult to photograph them walking. Make the rocks work for you and make them a part of the composition—in this photograph, they make up half of the frame. Shooting in this light necessitated an ISO of 640 to allow the 1/60th second shutter which halts the breaking wave.

Left: The gorgeous rocks on this beach were an integral part of the landscape. I was able to incorporate them by positioning the couple against them in the sand.

Opposite page: One of my favorite photographs to take is one of the couple walking on the beach in the sand, either hand in hand or cuddling. Sometimes the photograph of them walking away will be your best one!

*B*ride and Groom—Rain and Cold

During the consultation stage, most of my couples will ask, "But what if it rains?" It is good to talk about the possibility before the wedding day. This will give you a good idea of what your couple is willing to do. I am able to convince most of my couples that photographing in the rain and in the cold can be fun, and most will choose to do some photographs outside even in a downpour or on an icy-cold day.

Photographing in the rain and in the cold can be fun

I think that umbrella photographs can be quite beautiful, so I'll bring along a few large umbrellas if I suspect that it is going to rain.

If it is going to be very cold on the wedding day, I will suggest that the bride bring a wrap of some sort so that she can go outside for photographs without freezing. Some of the most beautiful skies that I have photographed have been taken on stormy days, and I like to show these to the couple before their wedding if there is rain in the forecast.

If the bride and groom do not wish to go outside in the rain or the cold, I bring candles with me (I keep these in the car, just in case). Candles can provide an intimate, romantic scene even in the ugliest indoor locations. I also try to look for locations that have beautiful light, or I will make my own with video light or a bit of fill flash with a dragged shutter. A lot of my indoor bride and groom photographs are intimate scenes that involve the bride and groom nuzzling each other, so it looks as if the photograph captured a private moment.

Above: The skies on a rainy day will usually be very dramatic—I try to convince my couples to go outside for a little bit. Sometimes they will even go without umbrellas!

Right: I love incorporating candlelight into the photographs on a cold, rainy day. To do so, you will need to shoot wide open with a fast lens. I suggest shooting on manual as your camera will want to underexpose when it sees the bright flames.

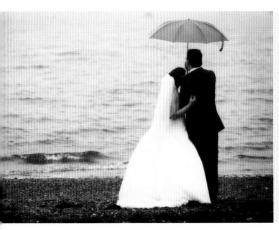

Left: If it is raining hard, it might be prudent to have an umbrella on hand. This couple wanted some photographs near the ocean, but it rained all day. This was a nice compromise shot.

Below: Sometimes you just won't be able to get outside due to inclement weather. Even then it is still possible to take some photographs in natural light that emphasize the surroundings. In this shot, we incorporated the entrance to the reception which was a beautiful, old stone building.

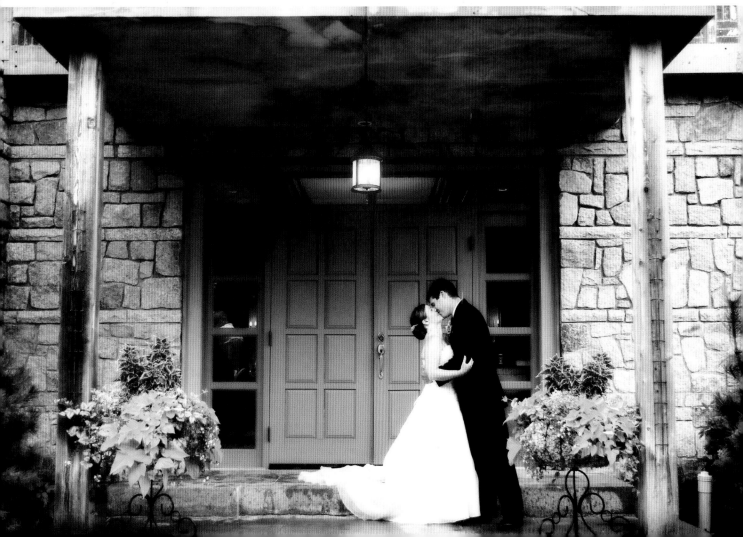

Details with the Bride and Groom

I like to photograph details using the bride and groom as an out-of-focus backdrop (using a wide aperture, a long lens, or both). Sometimes I can capture these during the day—the rose petals on the ground in the foreground and the ceremony out of focus in the background, or the cake in the foreground and the bride and groom dancing in the background.

Sometimes, however, I will set up my detail shots if I have some time left with the bride and groom. Often I am trying to photograph the bride's flowers in an interesting way—I will have the bride's hand, flowers, and ring in focus in the foreground with the groom out of focus in the background, or I will lay the flowers on the ground and photograph them in focus in the foreground with the bride and groom out of focus in the background.

Look for the things that have been set aside—sometimes the bride takes off her beautiful shoes to walk on the beach

Other possible detail shots are an interesting architectural element, a fountain, or a flowering tree in the foreground with the bride and groom in the background. Look for the things that have been set aside: for example, sometimes the bride takes off her beautiful shoes to walk on the beach—this is a good detail to have in the foreground while they are walking in the background.

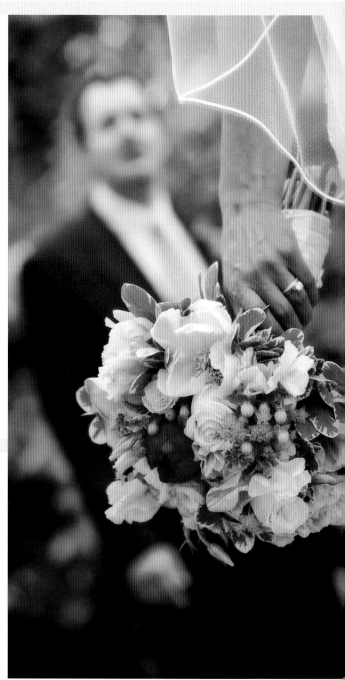

Far left: I wanted this to be a photograph about the flowers, but I wanted the bride and groom to be a part of it. I used a very shallow depth of field —with a focal length of 80mm and an aperture of ƒ2.8—to achieve the look.

Left: Once again, I wanted this photograph to be about the flowers, but I wanted to have a photograph of the groom looking at the bride in the background. To do so, I needed a shallow depth of field, but not so shallow that you couldn't tell who or what was in the background. To achieve this, I used my 85mm ƒ1.4 lens at an aperture of ƒ3.5.

Right: We headed to the beach to do some fun portraits of the bride and groom. The bride took off her shoes to be able to walk in the sand more easily. We took advantage of that by photographing her discarded shoes with the bride and groom walking in the background. I used an aperture of ƒ2.8 with my 80-200mm lens to take this shot.

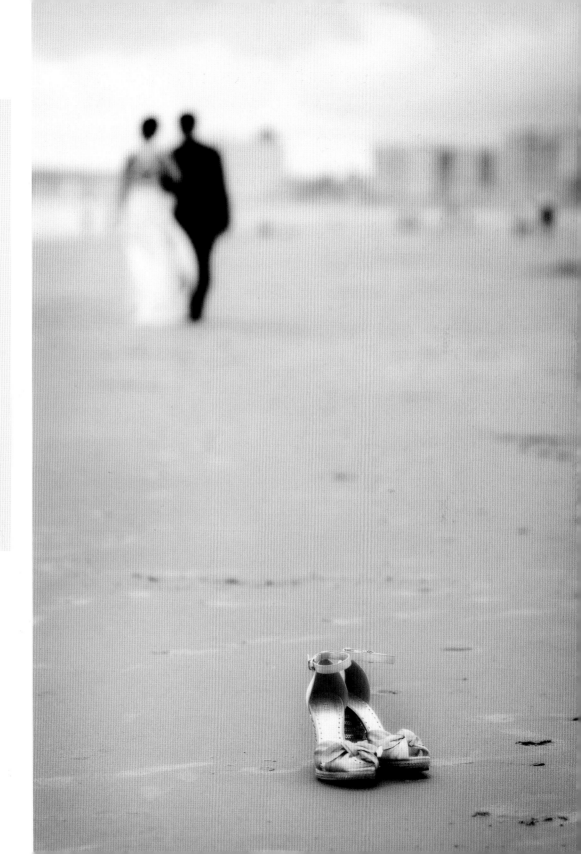

Reception Details

The reception is usually the result of many months (sometimes years) of planning. The flowers, the silver, the covers on the chairs, the flowers on the tables, the band, the place cards, the food itself—the reception is full of details that the bride and groom have spent a long time thinking about as the wedding day approached. I try to capture as much of it as I can. I want the bride and groom to look at the photographs and remember not only who was there, but also what kind of music was playing (a mariachi group? a harpist?), what kind of food they ate (lobster? steak?), how the tables looked, and what the room looked like as a whole.

Tables never look quite as good once the guests have started eating

I try to photograph many of these images as soon as I enter the reception—tables never look quite as good once the guests have started eating, and most couples want a photograph of their cake before they cut into it! Sometimes I have access to the reception room during the cocktail hour before the guests arrive. If I do, I leave the cocktail hour for a few moments to get these detail shots. If not, I try to take these photographs while dinner is being served.

Above: The Chinese lanterns, the hotel itself, the pool in the foreground—I wanted to include all of the elements in the photograph, and use a really slow shutter speed to capture all the ambient light as it was past dusk. I used my 16mm fisheye at ƒ2.8 and 1/10 of a second with a high 1600 ISO. The camera was stabilized on a chair since I didn't have a tripod with me.

Top right: The Mexican tiles and the flowers combine to give this destination wedding a Mexican feel. It was important that I capture this detail to add to the overall "destination" feel of the wedding.

Right: In order to photograph this night scene, I needed a slow shutter speed. I shot this with a 1 second shutter at an aperture of ƒ2.8. It was taken at a focal length of 17mm on a zoom lens.

Opposite: I wanted to include the doors in this picture to add to the rustic feel as well as to frame the photograph. This was achieved with my a 10.5mm fisheye lens at ƒ3.2 and 1/40th of a second.

Children

Children are fantastic subjects for photographs at weddings. If the bride and groom have invited children to their wedding or have them as part of the wedding party itself, they can often steal the show. I try to photograph them from afar throughout the day using a long lens—their faces usually show exactly what they are thinking if you don't interrupt them. I try to capture the excitement on the face of the flower girl as she puts on the pretty dress that she has waited so long to wear. I try to capture the look of boredom on the face of the ring bearer during the long, hot ceremony. I try to capture the dance floor with the children out there dancing.

Children can often steal the show

If there are any members of the bridal party or immediate family of the bride and groom that have children in attendance, I always try to take a quick photograph of the whole family. After all, it is not often that the children are dressed up and everyone is together, and they usually appreciate it and will purchase the photograph later.

It is important to remember if there are young children in the wedding party that you may not have time to compose the perfect shot. If I am setting up a formal photograph I will usually add a small child last as they do not normally have the patience to wait while other people are being shuffled around. There will be times when the children cannot wait to be photographed, and there are also times when they will be crying. I do not try to force a photograph with a child—if the bride really wants a photograph with the flower girl and the flower girl is crying, I try to convince the bride to save the photograph until after dinner or the child has taken a rest.

Left: This was taken using a 200mm telephoto during the ceremony.

Right: Again shot mid-ceremony at 200mm (EFL 300mm), this little girl refused to let go of the bride's dress, creating a cute series of photographs.

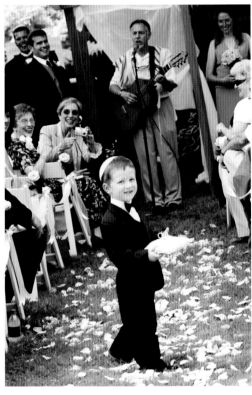

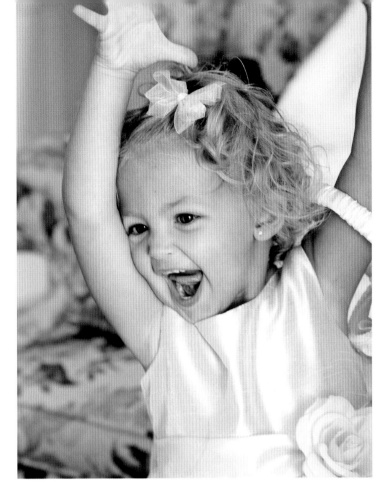

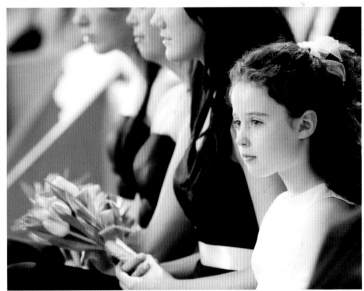

Above: Children are unpredictable—sometimes they ham it up for the camera and sometimes they run away as fast as they can. Be ready for either scenario! This little boy kept turning around and looking at me as he walked down the aisle—he loved the camera!

Top right: This little girl was so overjoyed when she saw her reflection with her "princess dress" on, that she threw her hands up in the air and giggled. This shot was caught at 85mm, aperture ƒ1.8.

Right: Keep your eye on the flower girls and ring bearers during the ceremony. They may fall asleep, sit quietly, or sometimes they will be up to something more devious. Either way, the child's perspective of the ceremony can be an interesting subject.

CHILDREN

peeches

This is one of my favorite parts of the reception. Emotions run high—I have never seen a series of speeches that didn't produce laughs, tears, smiles, or fantastic looks between the bride and groom. The people giving the speeches are almost always the people who are most important to the couple, so it is a good opportunity to get some great shots of them. And, finally, everybody (most of the time, at least!) is stationary, so I find it easy to take photographs even in the darkest venues.

I try to capture three things during the speeches: the speaker, the bride and groom reacting to the speech, and other guests reacting to the speech. I try to do mostly available-light photographs during the speeches (using my 50 mm f1.4, usually), although I will add a touch of flash (dragging the shutter to bring up the ambient light) if the faces are in shadow or if the reception is very dark. If I have a second photographer, I will have him in a good location to photograph the speaker while I photograph the bride and groom's reactions. This is a great opportunity to capture a series—there will often be wonderful and different expressions in quick succession, and you can capture the spirit of the speech by photographing the changing expressions.

Sometimes, because of where the speaker is standing, it is impossible to get both the speaker and the bride and groom in the same photograph. However, we always try to get at least one series of photographs in which they are all in the same frame. If they are facing one another, then we may frame the bride and groom with the speaker's out-of-focus side or hands, or frame the speaker in the space in between the bride and groom's heads to make a more dynamic photograph.

The people giving the speeches are the people who are most important to the couple

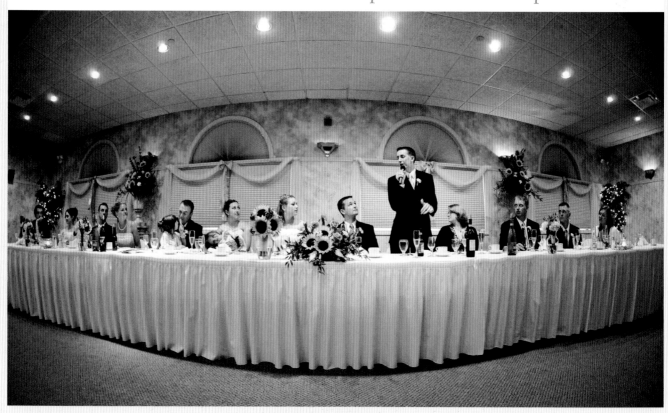

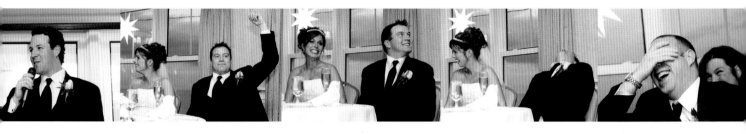

Above: Be ready for great photographic series during the speeches. Reactions can be absolutely priceless.

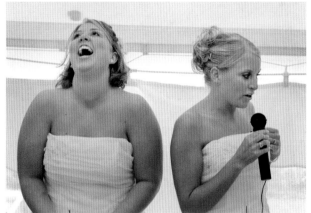

Opposite: I wanted to capture the entire table during the best man's speech, so I used my fisheye, and available light to keep the attention on the best man.

Left: Look to the left and the right of the person giving the speech—sometimes you can include a reaction in the same frame as the person giving the speech. Here, although the maid of honor looks serious, the other bridesmaid's reaction tells the true story.

Bottom left: This is one of the shots that almost every couple wants—a photograph of them toasting each other after the speech. If possible use available light, as I did here.

Below: Using the flash has the advantage of ensuring a crystal clear shot, important if you're trying to capture a momentary expression before the next sentence.

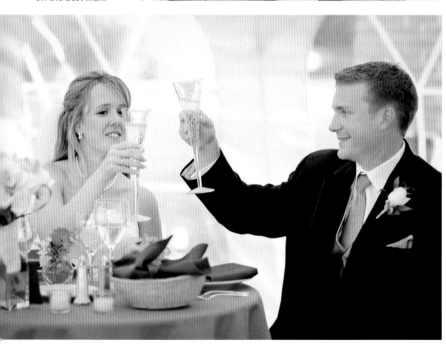

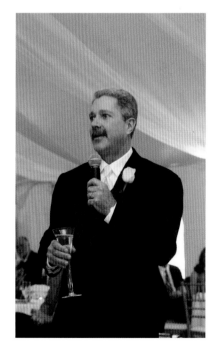

First Dances

Whether the bride and groom have choreographed their first dance or whether they are just winging it, you can produce some beautiful photographs of this part of the reception. I try to photograph this part with my 50 mm ƒ1.4 wide open (or close to wide open) so that the bride and groom are in sharp focus while you can see the crowd standing around observing, pleasantly out of focus. If I need to add flash, I usually photograph it at 1/30th of a second so that I can bring up the ambient light and still see all the onlookers clearly. Try to capture both close-ups (of the faces, and hands holding each other tight) and wider angles that capture the full scene. I also try to photograph the expressions of the parents while the couple is on the dance floor—often you will catch a tear or two rolling down someone's cheek.

For the most part, these are all existing light photographs

At most receptions there are also two other formal dances—the bride dances with her father and the groom dances with his mother. Most of the time they dance to two separate songs, but sometimes they dance to the same song. If one of the parents is deceased, the bride and groom sometimes invite all the remaining parents onto the dance floor for a group dance, or a grandparent will stand in. There are many different variations, so I always try to find out from the couple what they are planning to do. In addition to the close-ups of the expressions of those dancing, we also try to capture the expression of those around the dance floor, often in the same photograph. If the bride is dancing with her father, we try to capture them in focus in the foreground while the groom (often waiting with his mother or with the bride's mother) will stand in the background, smiling out of focus.

We also try to capture detail shots during the first dance. One of our favorites is to photograph the cake in the foreground while the bride and groom are dancing out of focus in the background. If they have a particularly elaborate centerpiece, this is another way to photograph that as well. For the most part, these are all existing light photographs, although we may add some video light to illuminate the bride and groom or to add some backlighting to the bride and groom if need be.

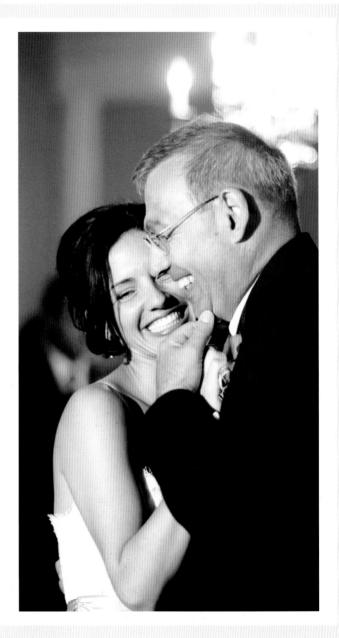

Above: The video light lifted the shadows and enabled me to capture this moment in an otherwise shadowy part of the dance floor without flash.

Right: I would like to say that I planned this, but it was serendipitous. The guest's flash adds another dimension to the shot.

Right: Be aware of background. Here the groom stands with the bride's mom while the bride and her dad share a first dance.

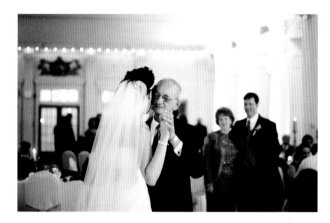

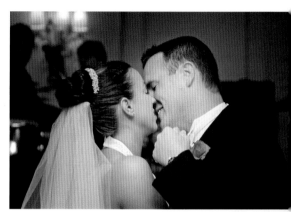

Far right: In a windowless reception hall, I needed the flash to add some light.

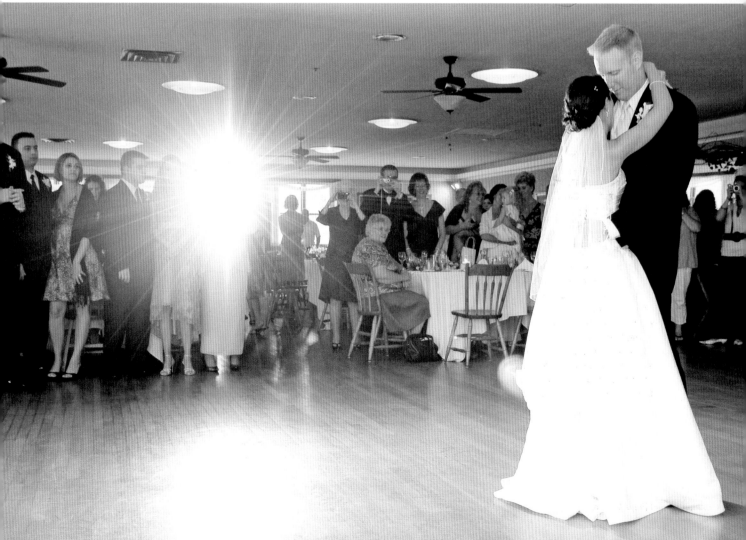

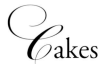

Cakes

Whether the cake is simple or elaborate, I always try to photograph it at some point in the reception before the bride and groom do the cake cutting. As previously mentioned, it may be used as a detail shot with the bride and groom in the background, or photographed by itself. We always like to have a photograph of it whole, though, before they cut into it.

You never know what kind of cake cutting you are going to get. I have had the most reserved couples chase each other around the reception with the cake and the most rowdy couples gently feed each other at the same time. I am prepared for either to happen—if I have a second photographer, one of us is using existing light at f1.4 or 1.8 and the other is photographing with a flash in order to capture any quick action.

This is a great opportunity to capture all the other cameras at the reception

This is also a great opportunity to capture all the other cameras at the reception. Usually the guests will congregate with their own cameras to take photographs of the bride and groom cutting the cake. It can make a great photograph to go around to the other side of the bride and groom and photograph them in the foreground cutting the cake with all of the guests in the background, cameras out and ready to capture the moment.

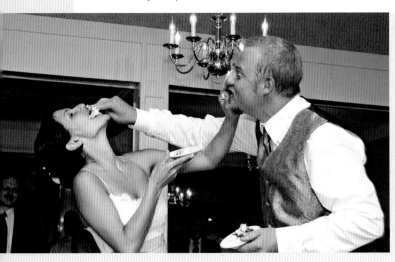

Far left: I can usually tell if a couple is going to smash the cake—but with this couple I had no idea! Be prepared to move quickly.

Left: I needed to add some flash to this photograph to get the detail in this chocolate cake. This was photographed at 1/60th of a second at ƒ5.6, ISO 800.

Right: The cake was positioned on the dance floor, so I used it as a foreground element in this picture of the couple's first dance. This was photographed at ISO 800 with my 85mm lens at ƒ1.8.

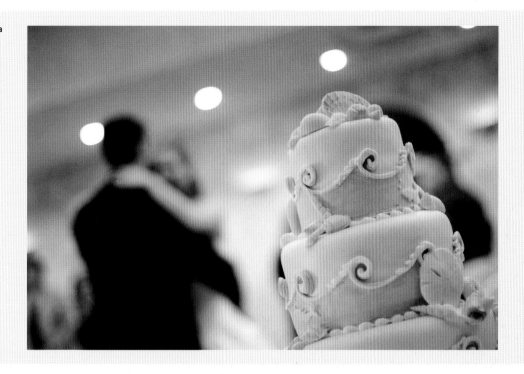

Below: Keep your eye out for special details. This cake was decorated like a terracotta pot.

Below: This was an interesting cake-cutting tradition—the groom used his grandfather's military sword to cut the cake.

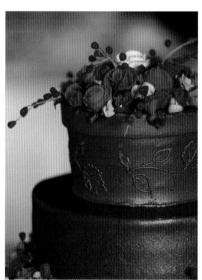

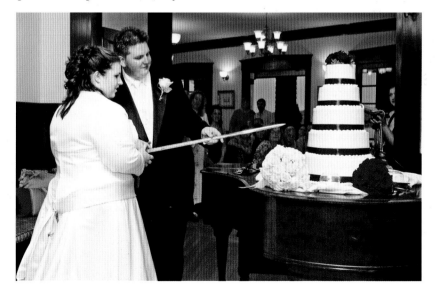

ther Events

I always check with the bride and groom to see whether they have any other events planned for the reception. At many Jewish wedding receptions, for example, they will dance the hora. Although less common now, some brides and grooms still opt to do a bouquet and garter toss. In such cases we try to position ourselves so that we have the bride or groom in the foreground with the crowd jostling to get the best catching position in the background. Sometimes this can get quite rowdy, with guests literally diving onto the floor to retrieve the bouquet or the garter.

Some brides and grooms still opt to do a bouquet and garter toss

However, I have seen many other special events—karaoke performed by some of the guests, a lip synch performed by the bridesmaids, fire dancing, poems that the bride and groom read for their parents—really, there is no limit to the special events that may happen during the reception. One very popular dance now in the

US is the Anniversary Dance—all of the married couples are asked out on the dance floor and start dancing. They are then dismissed based on the number of years that they have been married, until the couple that has been married the longest is the only couple left on the dance floor. If the bride and groom have grandparents at the reception, this is often a great chance to photograph them dancing. Even if they have limited mobility, the bride and groom will often try to get them to dance for just this song, knowing that they will be the last couple left on the floor. The last couple is often asked to give the bride and groom a bit of advice, or the bride and groom will present a gift (sometimes the bride's bouquet). This can be a very touching part of the reception. (The dance itself is a wonderful opportunity to photograph the married couples individually as they dance.)

Most of these special events are planned, but some are impromptu. If we are taking a break to eat we try to remain within earshot of the reception so that we can hear any of these last-minute special events, or if the reception coordinator decides to feed us in another room we ask the DJ or band leader (and usually the maid of honor as well) to send someone to get us from the next room if it looks as if something interesting is brewing.

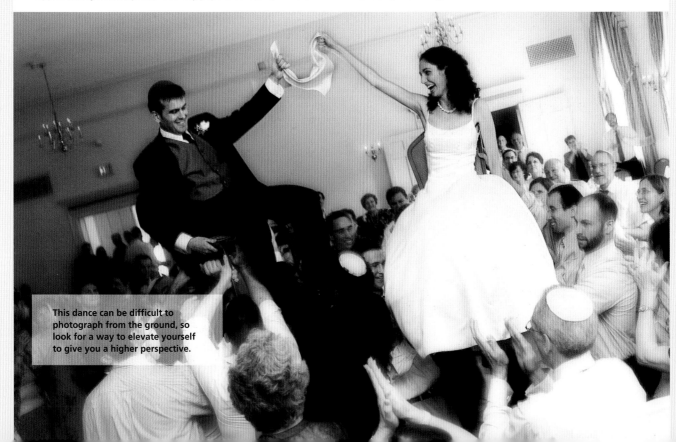

This dance can be difficult to photograph from the ground, so look for a way to elevate yourself to give you a higher perspective.

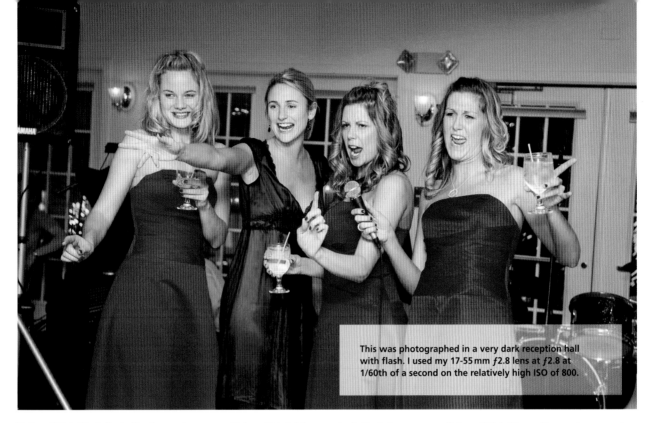

This was photographed in a very dark reception hall with flash. I used my 17-55mm ƒ2.8 lens at ƒ2.8 at 1/60th of a second on the relatively high ISO of 800.

Below: This bride dedicated her bouquet to her mom and read a poem. The shot was captured with the video light.

Below: This bride was a basketball star during high school—she and her dad played basketball before their first dance.

Below: This bride used her lacrosse stick to throw her bouquet out to the crowd.

*O*pen Dancing

It is during the open dancing that we feel that we capture the spirit of the reception. Some receptions are loud, raucous affairs while others are quiet and tame. We try to capture the spirit of both. First, if there is a band, we make sure that we photograph the musicians, often with a band member in the foreground and the dancers in the background. Second, we try to capture as many different guests dancing as we can— the bride and groom have invited all of these people and paid for them to be there, so we try to get a photographic record of as many of them as possible. Third, we always try to capture the parents of the bride and groom, the grandparents of the bride and groom, and the bridal party on the dance floor. Although we do try to capture everyone, we try to capture these people significantly more.

Many photographers use room lights to produce beautiful photographs

If there is a balcony or stage of some sort in the reception room or ballroom, we use it to get some elevation in order to shoot down on the reception. If not, we often just walk around the dance floor with a wide-angle lens. For most of the dancing (if it is an indoor or dark reception) we use on-camera flashes bounced off the ceiling or with a diffuser of some sort. For some receptions I may have my second photographer (or a tripod) hold a second flash that is triggered by my flash—this will add more depth to the photograph by adding light from another direction. Sometimes I use the second light as a backlight, while my flash illuminates the subjects.

There are many photographers who use room lights to produce beautiful photographs. I personally do not use them, but Neil van Niekerk (*www.planetneil.com*) has some fantastic tutorials on his site regarding the use of room lights to enhance and shape the light in the reception. There have also been many instructional threads on the Digital Wedding Forum (*www.digitalweddingforum.com*) on this same subject, often with diagrams and descriptions of how to position your lights and even suggestions about which lights to buy.

Right: The videographer's light adds some dimension to this flashed photograph—this could also be achieved with a second, off-camera flash.

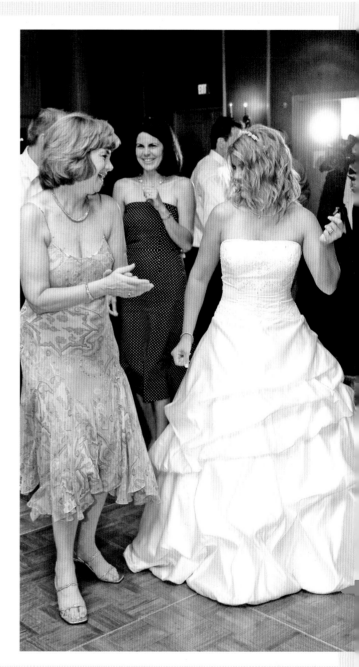

Top left: I try to photograph as many of the couple's close friends and family having fun on the dance floor as I can.

Top right: Here I used a slower shutter speed, and pointed the video light at the bride.

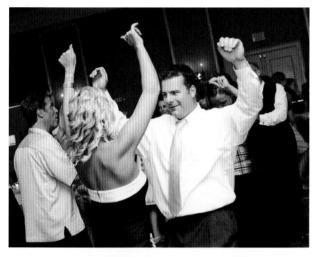

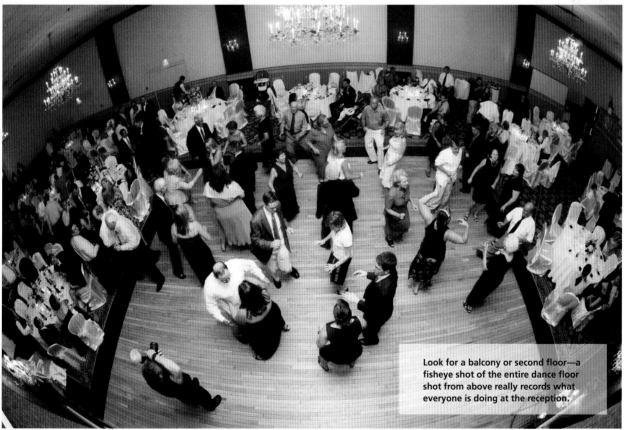

Look for a balcony or second floor—a fisheye shot of the entire dance floor shot from above really records what everyone is doing at the reception.

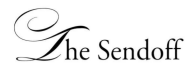he Sendoff

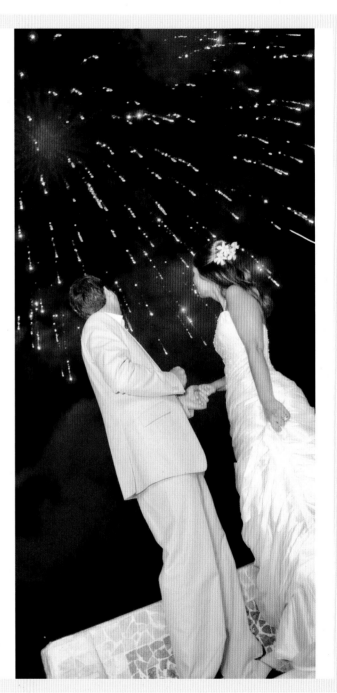

Sometimes the bride and groom will organize an elaborate sendoff, and sometimes the sendoff will be a surprise gift from parents or friends. The sendoff might just be a special last dance and the decoration of the bride and groom's getaway car, or it might be something that requires more planning and effort. The most common special sendoffs that I have photographed have involved fireworks or sparklers.

The sparkler sendoff is a fun way to photograph the bride and groom as they leave the reception—usually the guests have been lined up on either side with sparklers lighting the way as the bride and groom run through the aisle they have left between them. To photograph these we either use ambient light with a touch of video light to lift the shadows on the faces of the bride and groom or we photograph with flash on a slow shutter speed in order to bring up the ambient light and thereby emphasize the light coming off of the sparklers.

Fireworks are a bit more tricky, because it can be difficult to try to get the bride and groom and the fireworks in the same frame. If possible, I try to have the bride and groom elevate themselves—stand on chairs or on a low wall while I crouch down or even lie on the ground and shoot up at them. Once again, I use flash with a slow shutter speed to capture the full burst of the firework while lighting up the bride and groom. Often, because I am standing so close to the bride and groom, I may have to dial down my flash to -1/2 or -1.

If their getaway car has been decorated, I try to find out before the bride and groom actually depart

If the bride and groom have a special last dance, this is often a better time to photograph them than the first dance. They usually cuddle together and the guests are not afraid to crowd even closer than they were during the first dance, giving me a chance to photograph the bride and groom in an embrace surrounded by their close family and friends. If their getaway car has been decorated, I try to find out before the bride and groom actually depart so that I can sneak out of the reception and take some detail shots before the bride and groom drive away.

Right: If fireworks are going to be close or overhead, try to elevate the bride and groom so that you can get them in the same frame. Caught, with flash, at 1/30th second.

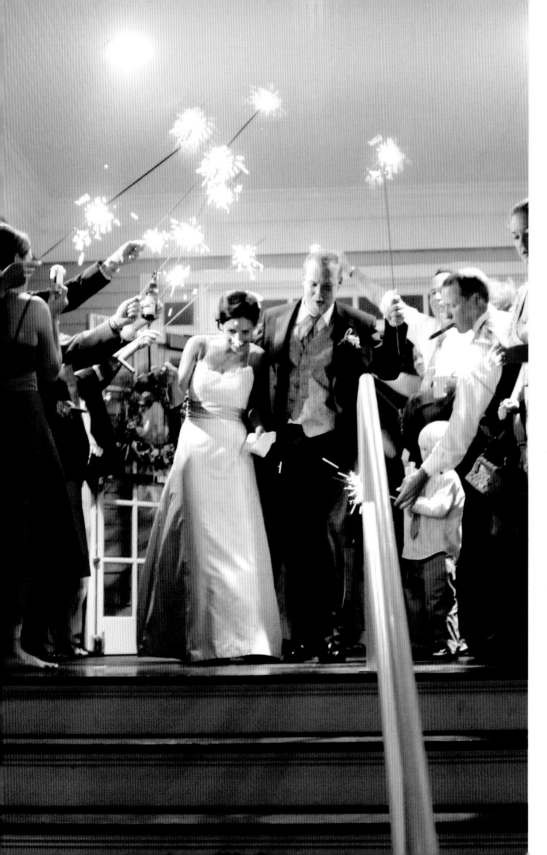

Left: This was photographed with my Nikon 28mm ƒ1.4 at 1/60th of a second, and ISO 1600. I wanted to capture a little bit of motion blur in this photograph rather than freeze my subjects entirely.

Below: Another fireworks photograph shot on manual at ISO 1600. The 1/15th of a second shutter creates tails, while the flash lights the couple.

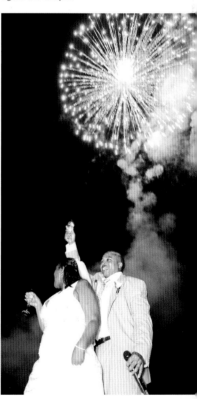

THE SENDOFF

The Day After Shoot: New Locations

I love it when the bride and groom commission me to shoot a Day After Session. They get dressed up (often in the wedding dress and tux again) so they look beautiful together, but they do not have the pressures of the wedding day. There are no time constraints, reception details, or guests to worry about. The day has come and gone, and they are completely relaxed. And, by this time, they are completely comfortable with me, and they aren't afraid to be openly affectionate with one another. The bride is also not afraid of getting the dress a little dirty—if she wants to keep it as an heirloom, however, I recommend that she buy a different white dress to wear that might be a bit more disposable. The same goes for the groom.

The day has come and gone, and they are completely relaxed

For the Day After Shoot, I either try to find different, interesting locations for our session or I may simply use locations from the day before that we didn't have time to get to. Sometimes the bride and groom are having their wedding in a coastal town, but not right on the beach, and there simply is not enough time to get there and get back to the reception in the timeframe that they have allotted. If this is the case, I will recommend a Day After Session—we often

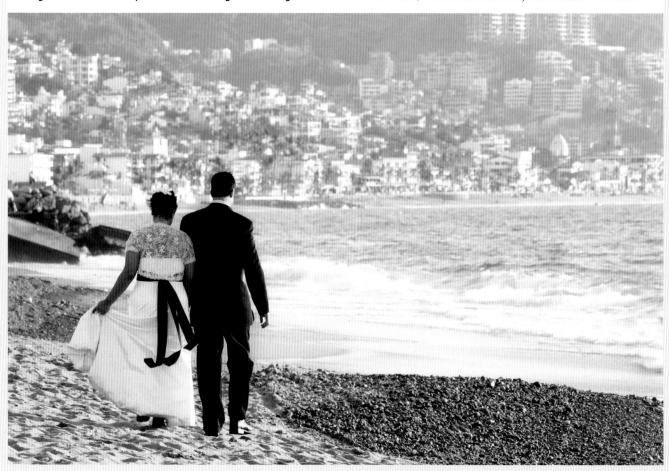

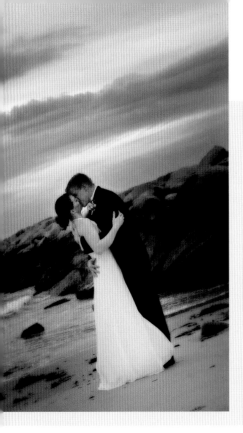

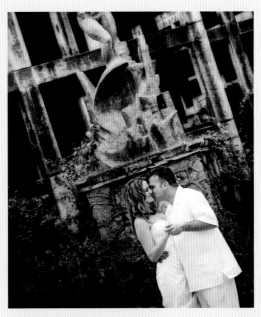

Opposite page: This couple was married in Mexico and they wanted some photographs of Old Town. I took the couple to a secluded beach uptown and photographed them walking away, with the town in the background.

Far left: In order to make this photograph possible without using flash, I processed it twice in Lightroom- once for the sky and once for the couple- and then merged the files in Photoshop.

Left: This photograph was taken in front of an abandoned, never-finished hotel. It was photographed at 80mm with my 80-200mm lens.

drive to several different, interesting locations. My Day After Sessions usually last about two hours, but have lasted much longer because I have so much fun doing them and the couple is usually having a great time as well. I feel as if I can step outside of the box on the Day After Sessions because of the lack of time pressure and "stay clean" pressure.

Although the beach is the most common request I get for a Day After Session, I have also done some fabulous urban sessions—lots of back alleys and forgotten side streets, broken-down vehicles and deserted factories. I have even photographed one of these sessions in the back of an empty 18-wheel truck!

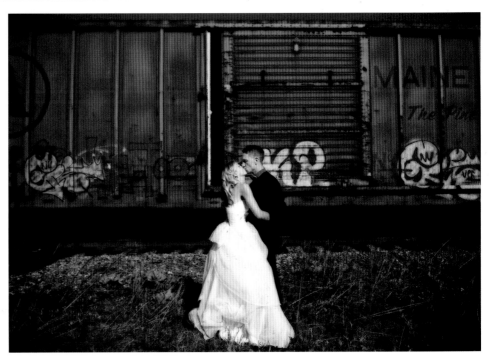

Right: This was taken in direct sunlight—the dark banking and dark rail car would have fooled my meter, so this was taken on manual, ISO 100, 1/2000 of a second at ƒ2.8.

The Day After Shoot: Getting Wet

This type of Day After Session is also becoming affectionately known as the Trash the Dress Session. It isn't for everyone (nor is it for every location)—typically I take the bride and groom to a beach, lake, or a river (or even a pool), and they often end up completely immersed in the water. With the right couple, this is a fantastic experience that allows you to get some incredible shots of the two of them together.

There are three shots that I always do in a Day After Session. For the first, I start them off easy—usually by having them go for a walk on the beach. I have them get closer and closer to the waves until they are walking in the water—this part of the shoot will provide some of the fun expressions—especially if the water is cold!

With the right couple, this is a fantastic experience

For the second shot, I have the bride and groom sit on the water's edge. If we are at a beach, I have them sit in a position where the waves will get them wet. If we are at a river or a lake, I have them sit partially immersed in the water. I usually have the bride sit in-between the groom's legs and lean into him with her back against his chest. Once again, I give them the same cuddling instructions that I gave them on the wedding day. Most of the time I can tell them just to cuddle and they will do it—if not, though, I tell the groom to kiss the bride from temple down to shoulder, going slowly. This is one of my favorite shots, and if it is safe to do so (no huge waves or current) I take this photo from the water, so that it is in the foreground of the

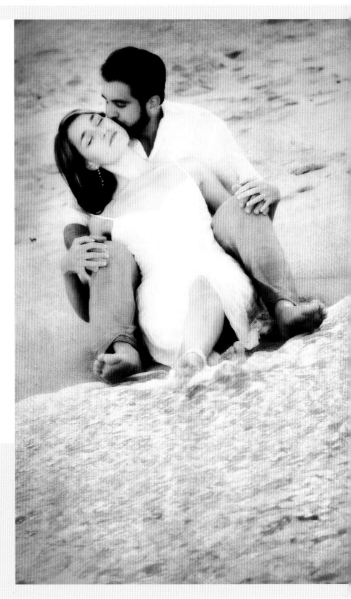

Left: This shot was taken with my Fuji S5 at ISO 400. It was taken with the 85mm lens, at 1/640 of a second at ƒ13.

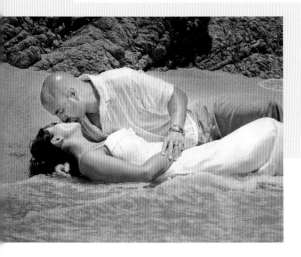

Above : Sometimes the best light is coming from the direction of the water. How, then, do you take advantage of the good light and get the water in the frame? By getting in the water and taking your photograph from there. Be careful, though—I almost got soaked taking this photograph.

shot rushing up to the bride and groom. Be aware of the waves behind you, though, and prepare to get wet!

For the third shot, I have the bride and groom lie on the beach, kissing. I try to set it up so that most of the waves will come up to the waist of the bride and groom—be prepared for the great expressions you will get if a bigger wave comes! If we are at a river or a lake, I will have them wade out into the water and kiss and cuddle in the water as the wedding dress swirls around the bride.

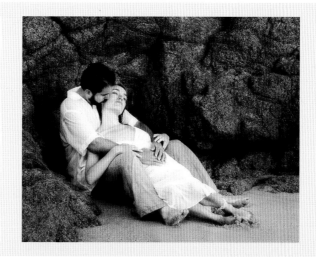

Left: I loved the texture of these rocks, so I used an action called "Boutwell Magic Glasses" from the Totally Rad Action Set to empasize them in Photoshop during post-production.

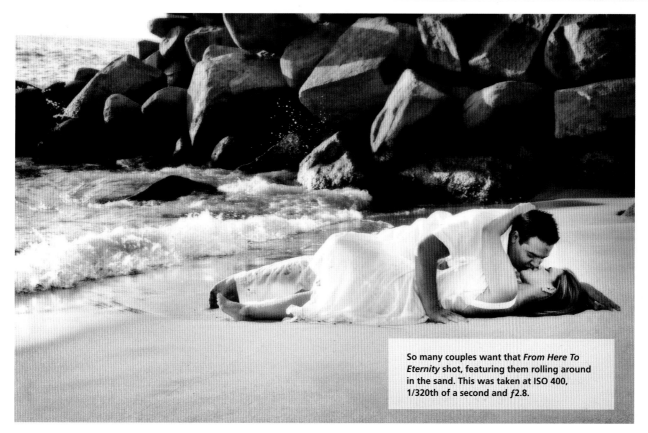

So many couples want that *From Here To Eternity* shot, featuring them rolling around in the sand. This was taken at ISO 400, 1/320th of a second and ƒ2.8.

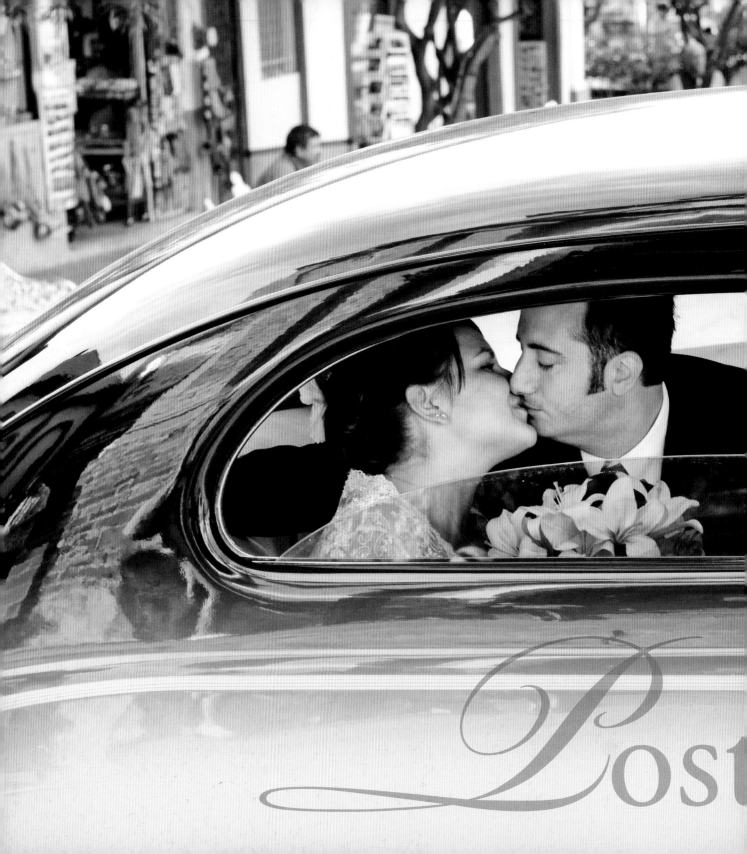

Photoshop has become part of everyone's vocabulary—as a verb as well as a noun. Often people say to me, "You can Photoshop that out, right?" However, while there are many things I can do in post-production to make a good image even better, there is very little that I can do to make a bad image into a good one. That is why the capture part of the equation is such an important one—I try to get the image as close to how I want it in-camera, before using two programs during post-processing—Adobe Lightroom and Adobe Photoshop. Using those programs is what this chapter is all about.

production

Workflow: Adobe Camera Raw

ACR is the acronym for Adobe Camera Raw, the RAW conversion software packaged with the latest versions of Adobe Photoshop. With the release of Photoshop CS3, you can now process your JPEG images in ACR as well, making it possible to perform minor exposure, white balance, and

1. Open
Open a folder of images in Bridge.

2. Sort
Since I use more than one camera on a shoot, I want to sort my images by time so that they are in the correct order. To sort by time, open your folder of images in Bridge, then go to *View > Sort* and select "By Date Created."

3. Rename
Once the images are sorted, I rename them. Click on *Edit > Select All*. Then select *Tools > Batch Rename*. The Batch Rename dialog gives you a few options—I just want to rename my images in the

contrast modifications alongside your RAW images. Although it is possible to access ACR directly by opening a RAW image in Photoshop, I find it easiest to deal with folders of images in Bridge, a program bundled with Photoshop.

same folder, though, so I select Rename in Same Folder. There are several ways to name your images, but the way I do it is by the job number, initials of the couple (select "Text" to input the initials), and a four-digit sequence number. For example, for Adam and Eve Smith, my 999th wedding, the file name would be 0999aes0001.jpg. Once my images are renamed, I go back to *View > Sort* and select File Name because I may create several versions of one image and I want those images to stay sorted together. Whenever I create another version of a file, I will add a letter to the file name. For example, if I make a heavily retouched version of the file 0999aes0001.jpg, the new version will be renamed 0999aes0001a.jpg. It is a long file name, but it allows me to easily manage and find hundreds of thousands of files.

4. Open the first image
I select my first image and double-click it. This will open the image with ACR. If any of the tools confuse you, simply hover your mouse over them and a dialog box will come up telling you which tool/menu it is. Make sure the Preview box is checked, or you will not be able to see any of your changes.

5. Set the white balance
Select the White Balance tool (the eyedropper that is the third from the left on the upper left). Put it on an area of the photograph that should be white and click. ACR will make any white balance

modifications that need to be made. If you need to adjust it, use the white balance temperature and tint sliders on the right side.

6. Tweak the exposure
ACR gives you the option of letting the program change the exposure. If you want to try it, click the Auto setting—often it can get quite close to the best exposure and then you can tweak it to taste from there. I'm usually pretty happy with my exposure, though, so I tend to simply add a bit of brightness and contrast to get my images where I want them to be.

7. Save your settings
Click "Done" to save your settings and return to Bridge.

8. Apply your settings to multiple images
The exposure and white balance are usually settings that I want to apply to batches of photographs under the same or similar lighting conditions. This saves time during the post-processing. To do this, select all of the photographs taken under the same lighting conditions as the photograph you have just tweaked. Then go to *Edit > Develop Settings > Previous Conversion*. Or you can go to the same menu and copy and paste, whichever you prefer.

9. Convert images to black and white
I occasionally do a grayscale conversion from within the ACR dialog. To do this, select the HSL/Grayscale Conversion menu from the right side under the RGB information. Click "Convert to Grayscale." Because it brings up the skin tones, I usually add a bit to the Red and Orange sliders, but you can tweak to taste.

10. Save your frequently used settings as a preset
If you use the same settings over and over again, you can save them as a preset. For example, with my S5 I usually need to warm the photographs up (add a little bit to the white balance slider), add a bit of brightness, and add some contrast. So I have made these settings into a preset that I apply to my S5 shots. To save a preset, select a photograph that has the settings you want applied to it, go to the Preset menu (under the RGB information on the right side) and click on the triangle to the right of the word "Preset." In the menu that opens, select "Save Settings." You can choose which settings you want to apply and name your preset. To apply a preset, simply stay in the Preset menu and click on the Preset you would like to use. Or you can apply these presets directly from Bridge. Select *Edit > Develop Settings* and then choose the preset you wish to apply. Bridge will apply the settings to your previews (not to the original photograph—you will have to go to Image Processor or open the image in Photoshop to do this) so that you can scroll through them and make individual adjustments, if needed.

11. Crop and straighten
It is also possible to crop and straighten files directly in ACR. I usually do not do this unless I want to straighten a horizon, but some people choose to crop during this stage of image manipulation. To crop, select the Crop tool (from the upper left) and drag it across the image until you have selected the area of the image that you would like to include. To straighten the image, select the Straighten tool (from the upper left, next to the Crop tool) and drag it across a horizontal line in the image that you want to straighten (such as a horizon).

12. Export
Once you have finished making adjustments to your photos, you are ready to process them. Select all the files that you want to process, then go to *Tools > Photoshop > Image Processor*. This will open Photoshop and the Image Processor dialog box. I don't ever want to overwrite my JPEG files, so I always save to a new folder. You have a choice of how you want to save your photos—I save them as a JPEG, quality 12. This is the highest level JPEG. You can also save as a TIFF or PSD file.

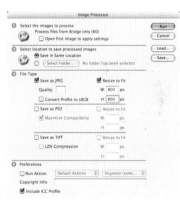

With the release of Photoshop CS3, you can now process your JPEG images in ACR

Lightroom is a fantastic tool for processing images. It gives you the opportunity to maintain a large library of files and, like ACR, gives you the ability to process your RAW files alongside your JPEG files. Indeed Lightroom was written from the ground up to treat these formats equally from the user's perspective, while taking advantage of the masses of under-the-hood digital detail that make up RAW files. My workflow for Adobe Lightroom is virtually identical to my workflow for ACR, so I am going to speed through that and spend more time on some of the features of Lightroom that I really like.

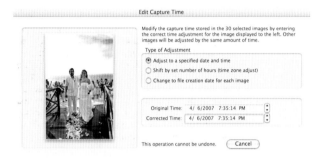

1. Changing the time stamp

I shoot with the Fuji S5 and the Nikon D2X and Nikon D200. It is very easy to sync the time in the D2X and the D200, but difficult to sync time with the S5 because it only lets you change minutes, not seconds. If you have a similar camera or if you simply forget to sync time in your cameras before the shoot, you can change the time stamp in Lightroom. If you notice that time of one of your cameras is off, find a photograph from each camera taken at almost the same time. I pick something like the first kiss because I usually have a photograph of it on each camera. Select one of the kiss photographs and look at the time stamp (in the Library mode, scroll all the way down on the right menu slider to look at your metadata). If my S5 has the kiss happening at 4:42:15, I will want to change the time stamp on the D2X files. First, I select all of the files taken with the D2X. To do so, in Library mode scroll all the way down the left menu slider to find the Cameras. Select the D2X- Lightroom will then only show the files taken with the D2X. *Edit > Select* all, and then choose the kiss photograph. I want to set this photograph to 4:42:15 as well, so I select *Metadata > Edit Capture Time*. Not only will it adjust that file, but it will also adjust every other selected photograph by the same amount of time.

2. Editing out the rejected files

Lightroom is a fabulous tool for editing your files. On the bottom panel you will see "Filters" and then three different flags. The first flag is "Picks only," the second flag is "Unflagged Photos Only" and the third flag is "Rejected Photos Only." If you click on these flags, you will affect which photos you see in the Lightroom grid. I edit by clicking on the first two flags (Picks and Unflagged) while leaving the third (Rejected) unclicked. To reject a file, hit the letter X and the photo will disappear from the grid. This is a great method because if I change my mind and want to keep the photo, I can simply remove the "rejected" flag since I haven't actually deleted the photograph from the library. To remove the rejected flag, you will need to click on the third flag at the bottom—this will allow you to see the rejected files as well. Then, simply select the photograph from which you want to remove the flag and press U. To hide the rejected files again, uncheck the third flag.

> ## Lightroom gives you the opportunity to maintain a large library of files

3. Editing in the "Picks"

If you edit in instead of editing out, that is simple to do as well. From the grid, hit P if you want to flag a photograph as a pick. Then to only view the picks, go to the Filter flags on the bottom and select only the first flag. Lightroom will show you a grid comprised of the picks.

4. Creating and Custom Black and White

Go to the Develop module and scroll down on the right menu slider until you see HSL/Color/Grayscale. Select Grayscale, and your photograph will be converted to black and white. Lightroom will automatically select a Grayscale mix that it thinks works for your photograph. You can play with the sliders to change the grayscale mix, or if you prefer you can select an tone in the photograph that you want to change and only affect that. This works especially well with skin tones, if they show up too light or dark. To do this, select the little bullseye on the left underneath the HSL/Color/Grayscale menu heading. Then select a spot in the photograph that has a tone you

want to change—if a skin tone, I select the skin on the face. Then, while clicking, move your mouse up (to lighten that tone) or down (to darken the tone). Watch out though—all similar tones in the photograph will be affected.

5. Creating and Saving a Preset

Once you've created a black and white image, it is easy to create and save presets. For example, I like my black and whites to have a warm tone to them. So, I am going to create a black and white preset. First, I create a grayscale image as detailed. Then I go to the split toning menu (on the right menu slider in the Develop module) and tone the shadows. Brown tones occur around a hue of 40, so I select 40 with a saturation of approximately 20, but you can tweak to taste. To save this as a preset, go to the left menu slider in the develop module and select the plus sign next to "Presets." There are also several presets available for free and for purchase on the web—some really great ones belong to Kevin Kubota (*www.kubotaimagetools.com*).

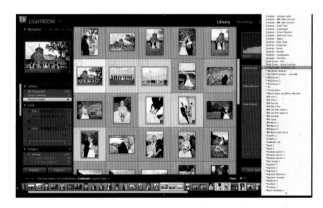

6. Applying Presets in a Batch

Now that I have created my Warm Black and White Preset, I want to apply it to a batch of images. In the Library grid, select all of the photographs that you want to apply the preset to. Then go to the right menu slider and under Saved Preset select the preset that you want to apply.

Above: Lightroom can handle file exports from within the program itself, including creating folders, resizing files, adding sequential numbers to their names, and many other useful facilities.

\mathscr{P}hotoshop Essentials

Photoshop CS3 is a truly amazing application that provides virtually limitless flexibility when enhancing and customizing your images. There are some tools within CS3 that can make editing a much easier job and decrease the amount of time that you spend in front of the computer. My Photoshop essentials include Actions, Scripts, Keystrokes, and Layers.

ACTIONS

You can either make your own actions or purchase ready-made actions, but either way actions will save you a lot of time by applying a number of adjustments to your images. To use actions, simply open the image you want to work on and either select the action from the Action bar and click "Play," or, if you are in button mode, click the action in the Action bar.

I make a lot of my own actions, but I also buy and use pre-made actions. The actions I use every day come from Boutwell Studios (*www.totallyradactions.com*), Kevin Kubota (*www.kubotaimagetools.com*), and iDC Photography (*www.idcphotography.com*—specifically the "Textures with Actions" from the Digital Tools part of the site). There are also some great actions available from Kevin Jairaj (*www.kjimages.com/actions/*), Jeff Ascough (*actions.jeffascough.net*), Craig Minielly (*www.craigsactions.com*), DQ Studios (*www.dqquikeys.com*), and Dawn Roberts and Barb Uil (*www.ittybittyactions.com*).

SCRIPTS

These are also huge timesavers in CS3. Scripts allow you to run a set of actions in Photoshop, and the great thing about scripts is that they can be conditional. For example, if you want to apply the same border to a set of images that includes images of different sizes and of portrait AND landscape orientation, scripts are what you want to use. There are two scripts that I use for every wedding. For the most part, scripts are accessed from *File > Scripts*, although some scripts are accessed through the *File > Automate* menu.

The first script I use comes free with CS3. It is called Image Processor, and it allows you to take a folder of images and apply actions, resize, and save them to a different folder all in one step. The great thing about this is that you can set it to start working and then walk away from your computer and come back when it is done. It is accessed from *File > Automate > Image Processor*.

The other script comes from Mike Dickson (*www.photosforlife.ca*—click on "Tools for Photographers"). Mike offers a few different scripts, but the one I use every day is called AutoLoader. What it does is take a folder of images and automatically open them one by one in Photoshop with one keystroke that you set yourself.

Then, when you are finished working on the images, it saves them to the folder you specify in the format you specify with the same keystroke. This script has cut my editing time in half because it allows me to go through an entire folder of images without manually opening or saving them.

KEYSTROKES

If you make certain adjustments in Photoshop often, you can apply them using keystrokes. For example, I use the Shadow/Highlight tool a lot to open my shadows by about 10%. Rather than clicking on *Image > Adjustments > Shadow/Highlight* every time I want to open this adjustment, I have assigned it a keystroke. To assign a keystroke, go to *Edit > Keyboard Shortcuts*, navigate to the menu/adjustment you want to open and then assign it a key. You will be amazed at how much time this simple change will save you.

LAYERS AND LAYER MASKS

Layers are great tools because they let you apply changes to an image on a separate layer. The benefit of this is that if you overdo something (for example, apply too much skin softening), you can lower the opacity of the layer and thereby decrease the effect. I always apply any image changes on a new layer. To create a new layer that is a copy of your image, select *Layer > New > Layer Via Copy*. Then, with that layer selected, make any changes you want to make on the images. If you go too far, simply lower the opacity of the layer (the opacity slider is above and to the right of the layer bar).

Another important tool from within the Layer menu is the layer mask. Perhaps you like the effect you have created but only want it applied to part of the image. Instead of lowering the opacity of the whole layer, add a layer mask. Click on the layer you want to adjust in the layer bar and then click "Add a Mask" (the third tool from the left on the bottom of the layer bar). The mask will show up as a solid white box next to the layer in the Layer tab. Select a black brush (or, if the layer mask shows up as black, select a white brush) then paint on the image. It will gradually erase out the layer you have selected, thereby decreasing the effect. If you go too far, select a brush that is the same color as the mask and paint on the image again.

There are some tools within CS3 that can make editing a much easier job

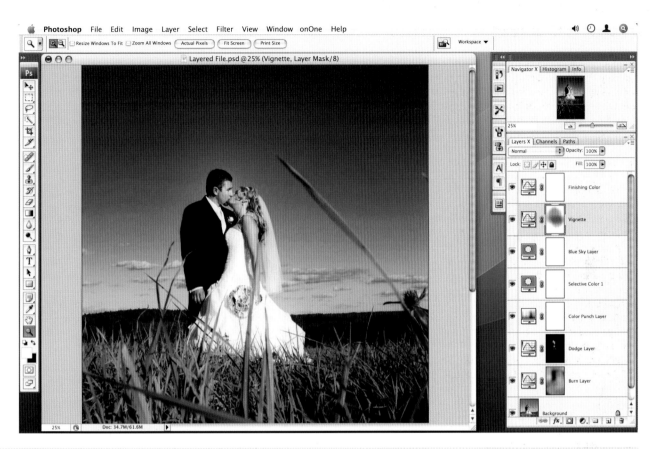

Right: Some of Photoshop's most useful windows include the Actions panel, where you can store a series of steps to reuse whenever you need, and the Image Processor, which can perform an action on a batch of images and re-save them in a new format.

Far Right: The AutoLoader script can save you time when editing multiple images by opening and saving them automatically to the folder of your choice.

PHOTOSHOP ESSENTIALS

*E*volution of an Image 1

Step 1: The first thing I want to do is dodge (lighten areas of the image) and burn (darken areas of the image). I use adjustment layers rather than the Dodge and Burn tools, however, as I find that the Dodge and Burn tools can affect your colors.

a *Layer > New Adjustment Layer > Curves* (there is also a shortcut button for this on the bottom of the Layers tab).

b Pick a spot in the center of the line and drag it up toward the upper left corner. This will lighten the image considerably. It will look strange at this stage as it will apply the changes to the whole image.

c You already have a layer mask for this layer—it is white. However, in this case it's preferable to paint the effect in, not paint it out. So select the Paint Bucket in black, make sure the layer mask is selected (click on the white box next to your layer once) and click the Paint Bucket over the image. It will fill your layer mask with black, hiding the effect. Switch to a soft, white brush at about 20% opacity and paint back the effect in areas that you want lightened. In this image, I dodged her face. The more you paint, the more you lighten.

d Make sure the Background layer is selected in the Layer tab. Then click *Layer > New Adjustment Layer > Curves.*

e Pick a spot in the center of the line and drag it down toward the lower right corner. This will darken the image.

f As in Step 1c, make your layer mask black and then paint in areas of the image with the white brush to darken the image. In this image, I want to darken the car background and parts of her dress.

g I then flatten the image (*Layer > Flatten Image*), although there are many who save that for the last step.

Step 2: Next, I want to enhance the color through a new layer.

a *Layer > New > Layer via Copy.*

b Change the blending mode of the layer to Soft Light or Hard Light (click on "Normal" under the Layer tab for the pop-up menu).

c I like the effect everywhere but her face, so I add a layer mask. This time I want to paint the effect out, so I leave the white layer mask and select a soft black brush at about 20% opacity. I brush the effect out of her face.

d After this I flatten the image as before.

Step 3: Here I want to add a slightly cross-processed look to the image. There are several Photoshop actions that can do it and various different methods, but here is a system that I like and have tweaked to my own tastes:

a Create a new curves adjustment layer using the Create New Fill or Adjustment Layer at the bottom of the layers palette.

b Select the Red Channel from the Channel dropdown in the Curves menu. Drag the upper right corner a little to the left. Then click a point on the upper right of the line and drag it up a little. Click a point on the lower left of the line and drag it down a little.

c Select the Green Channel and select a point on the upper right of the line and drag it up a little. Select a point on the lower left of the line and drag it up a little.

d Select the Blue Channel and drag the dot in the upper right corner down a little and the dot in the lower left corner up a little.

e Click OK and adjust opacity of the layer to taste, or add a layer mask and paint the effect out of part of the image.

f Flatten the image.

Step 4: To erase blemishes and soften the skin, and enhance the eyes I start with the Spot Healing Brush, targeting any blemishes or skin discolorations. There are a lot of skin-softening and eye-enhancement actions out there that I like and use (my favorite is Pro Retouch, part of the Totally Rad Actions), but if you don't want to buy one, here is a quick method:

a *Layer > New > Layer via Copy.*

b *Filter > Blur > Gaussian Blur* at a radius of 4 pixels.

c Add a layer mask and make it black with the black paint bucket so that you have to paint the effect in. Select a small, soft, white brush and paint some of the blur into the skin. Avoid the eyes, lips, clothes, and hair.

d Flatten the image.

e Repeat Step 1. This time, I dodge her face again (I want to lighten it even more) and the whites of her eyes. I burn the background as well as the area around the eyes to make the eyeliner more dramatic.

f Flatten the image.

*E*volution of an Image 2

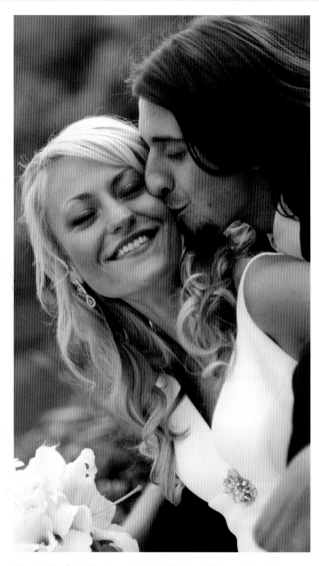

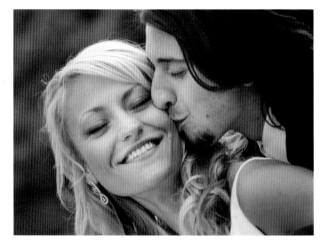

Step 2: Even though I adjusted the white balance in Adobe Lightroom, the image still looks a little blue. One way to warm it up is to use a Photo Filter adjustment layer. Select a warming filter at about 30%.

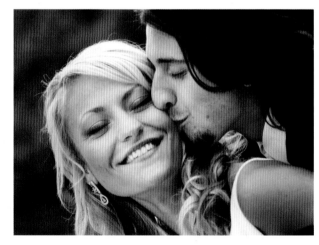

Step 1: The first thing I want to do is dodge and burn. Follow the masking procedure in Evolution of an Image 1, Step 1 (see page 104). In this image, I want to lighten the couple's faces and darken the flowers and the background.

Step 3: To enhance the colors, flatten the previous steps and duplicate the layer (*Layer > New > Layer via Copy*). Then change the layer blending mode from Normal to Hard Light, but to reduce the effect in their faces, add a layer mask and paint it out a little.

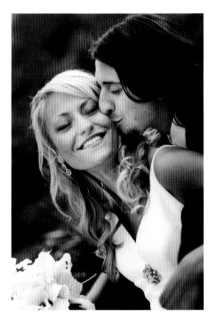

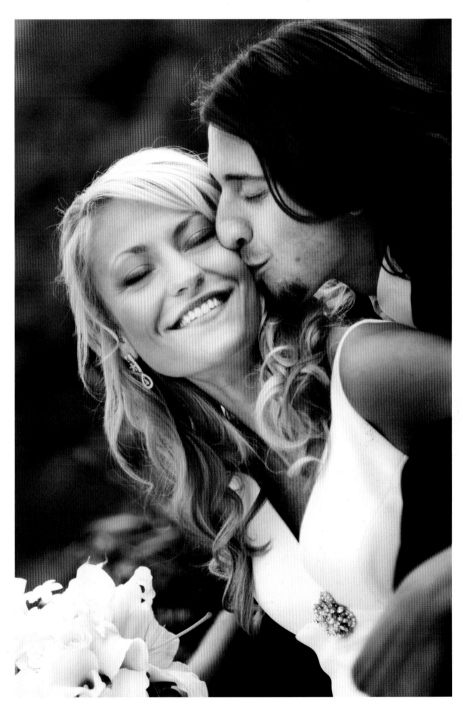

Step 4: Add a vignette to darken the edges.

a *Layer > New > Layer via Copy.*
b Select the Lasso tool, set the feather at 150 pixels and draw around their heads and part of their bodies.
c *Select > Inverse.*
d *Image > Adjustments > Levels.* Slide the Midpoint slider (the Gray one that begins in the center) to the right to darken the edges.
e *Select > Deselect.* Adjust the opacity of the layer and flatten.

Soften the skin and lighten the circles under their eyes

Step 5: Soften the skin using the same method as the first example (see page 104). Also lighten the circles under their eyes. There are a number of methods—here I have used the Clone Stamp tool. Add a new layer. Select the Clone Stamp tool with a small, soft brush, set it to Lighten (under Mode) with an opacity of 15%. Select a lighter, unblemished area of the skin, and then paint out the circles. If you go too far, lower the opacity of the layer.

*E*volution of an Image 3

Step 2: Next, I want to dodge and burn the image slightly using the technique from Evolution of an Image 1, Step 1 (see page 104). Specifically I am looking to lighten her face and darken almost everything else.

I am looking to lighten her face and darken almost everything else

Step 1: The shadows look a little compressed in this first image, so I want to open them up using *Image > Adjustments > Shadow/Highlight*. In the box that opens, I select 15% for the Shadow Amount, with a Tonal Width of 50% and a Radius of 30 pixels. I leave the Highlight at 0%. This will make her hair stand out from the darkness behind it.

Step 3: To give the color and contrast a boost create a duplicate layer (*Layer > New > Layer via Copy*), and change the blending mode from Normal to Soft Light. Although I like what this does to most of the image, it has compressed the shadows to the point that her hair blends into the background again. Create a layer mask and paint the effect out of her hair (*Layer > Layer Mask > Reveal All*).

Step 4: I want to enhance her eyes. First, I am going to actually enlarge her eyes a small amount. Next, I am going to dodge the whites of her eyes and enhance the eye color.

a To enlarge the eyes, go to *Filter > Liquify* and select the Bloat tool. With a brush density of around 75, a brush pressure of around 25, and a brush rate of around 80, I select a brush that is slightly bigger than one eye. Positioning the pupil at the center of the brush, click—the eye will get slightly bigger. Repeat for the other eye. This also works really well for people who have one eye that is smaller than the other. Be careful, though—it is really easy to overdo this effect.

b To enhance the eye color, I want to do two things. First, I want to add to the saturation. *Layer > New > Layer via Copy*. Go to *Image > Adjustments > Hue/Saturation*. I want to leave Hue alone, add 50 to Saturation, and add about 5 to Lightness. Because I only want to apply this to the eyes, I am going to add a layer mask, make it black with the black paint bucket, and then paint back over the eyes with a small, soft, white brush. Be careful not to paint the rims of the eyes, or they will look very red.

c A good finishing touch is to dodge the whites of her eyes and burn the eyeliner and the rim of her iris. I do this using the dodge and burn procedure from Evolution of an Image 1, Step 1 (see page 104).

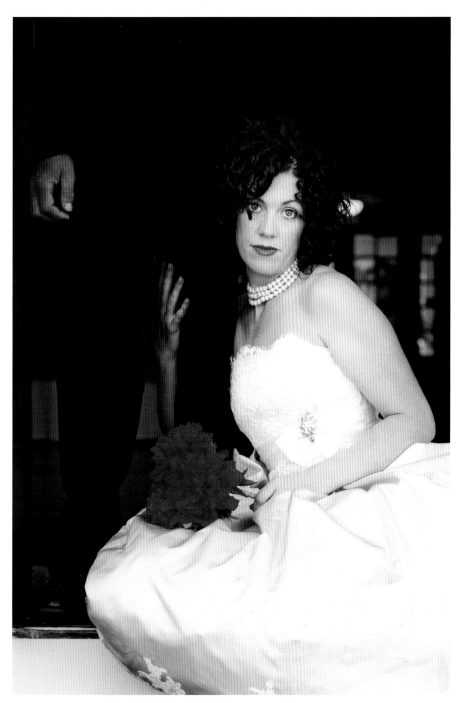

&volution of an Image 4

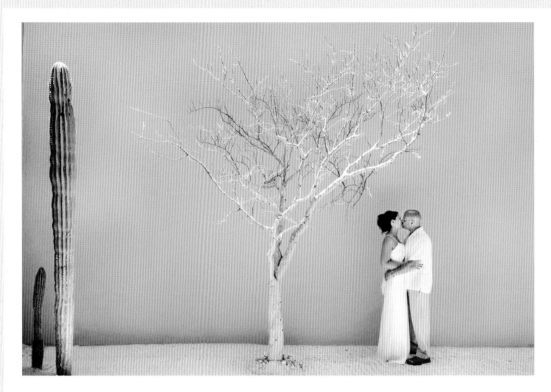

Step 1: First I want to dodge and burn the image. Specifically I want to dodge the couple and burn the cactus and the sand. To do this, I use the dodge and burn procedure from Evolution of an Image 1, Step 1 (see page 104).

There are plenty of textures available on the internet

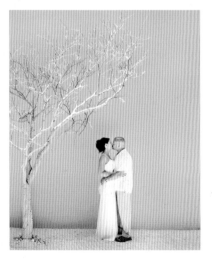

Step 2: I want to enhance the color.

a *Layer > New > Layer via Copy* and change the blending mode from Normal to Soft Light.
b Flatten the image after adjusting the image opacity to taste.

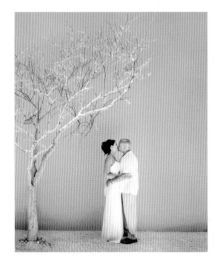

Step 3: Next I want to add a vignette to darken the edges.

a Select the Lasso tool at about 200 pixels (since we are selecting such a large portion of the image) and draw around the center of the image.
b *Select > Inverse.*
c *Image > Adjustments > Levels* and slide the middle, gray slider to the right slightly.
d *Select > Deselect.*

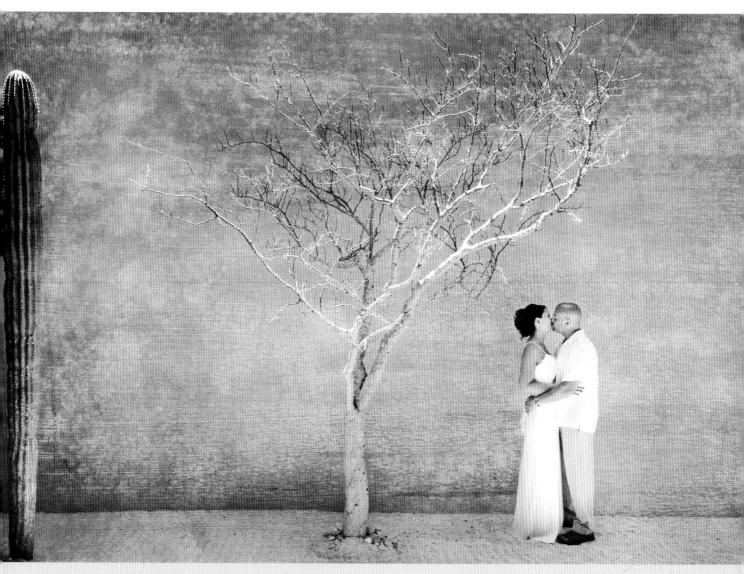

Step 4: I want to enhance this image by using a texture. There are plenty of textures available on the internet for purchase, or you can photograph your own (walls, cement sidewalks, wooden panels, for example) and drag it on top of the image as another layer, adjusting the image opacity so that most of the original shows through. However, some of the best textures available come from Bruce Dorn and Maura Dutra's website (*www.idcphotography.com*) and I will be using one of those to enhance this image.

a Select a texture/action—for this one, I have chosen Artifact Color: Texture. Play the action, then reposition the texture. The instructions will tell you to paint back through the texture with a brush—here I want to paint back their skin and clothes, the cactus, trunk of the tree, and most of the sand.

b Flatten and Save.

&volution of an image 5

Here is a black and white image—I converted this to a simple black and white in Lightroom by clicking Grayscale and letting Lightroom pick the grayscale method.

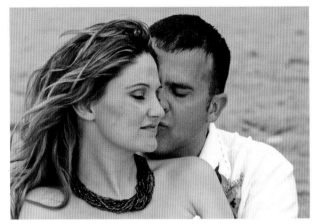

Step 2: Their faces are still dark and the dress is very bright. To draw attention to their faces I once again dodge and burn (see page 104). It's worth taking time to manually "paint" areas using these tools as the computer cannot see what areas are important to the human viewer.

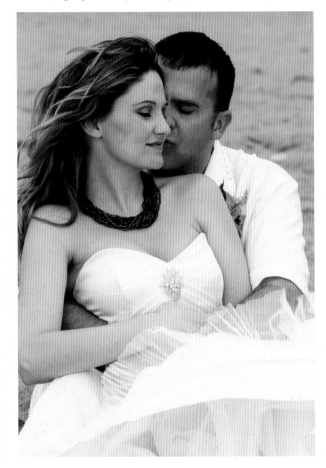

Step 1: The shadows look blocked up in this image, especially in the hair area, while the dress looks overly bright. The Shadow/Highlight tool is able to intelligently solve this.

a *Layer > New > Layer via Copy.*
b *Image > Adjustments > Shadow/Highlight.*
c I set my shadows at 15%, tonal width 50%, and a radius of 30 pixels while my highlights are set at 5% with a tonal width of 50%, and a radius of 30 pixels.
d Flatten the image.

Step 3: I want to add some warmth to this black and white. I want to leave the highlights white but give the shadows a tinge of brown to warm it up.

a *Layer > New Adjustment Layer > Gradient Map.*
b Double-click the gradient that comes up—this will bring up the Gradient Editor, with which you can alter the tones.
c The gradient has four boxes with arrows pointing to it—select the box in the lower left corner and double-click inside the box. This will bring up a box called Select Stop Color.
d Select a very dark brown. This will warm up your shadows. You can play around with the color selection until you find something that you like. If you want to cool your shadows, you can select a deep blue color.
e Flatten the image.

Step 4: This image will be enhanced by creating more contrast.

a *Layer > New Adjustment Layer > Curves.*
b Select a point on the line in the upper right and pull it slightly up (toward the upper left corner). Select a point on the line in the lower right and pull it slightly down (toward the lower right corner).
c Flatten the image.

I converted this to a simple black and white in Lightroom

Step 5: Add a vignette.

a Select the Lasso tool and set it to feather at 200 pixels. Draw a circle around their heads and upper bodies.
b *Select > Inverse.*
c *Image > Adjustments > Levels.*
d Pull the middle slider to the right to darken the edges of the images.
e *Select > Deselect.*

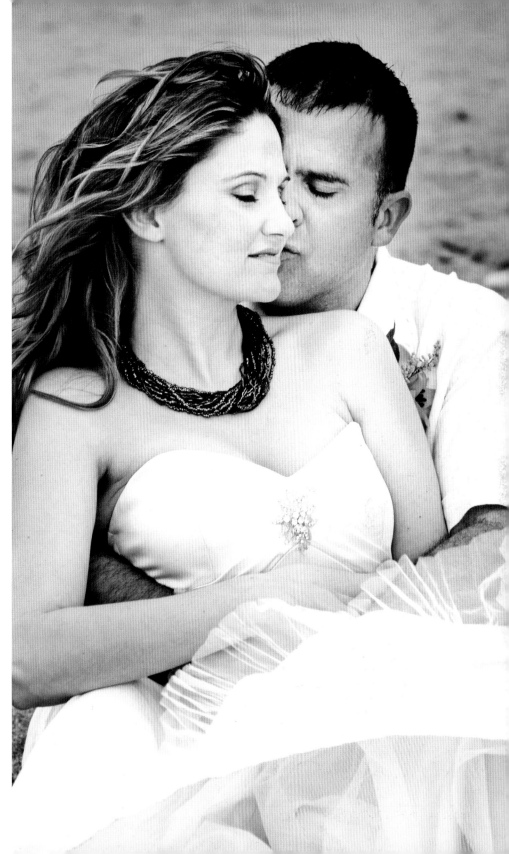

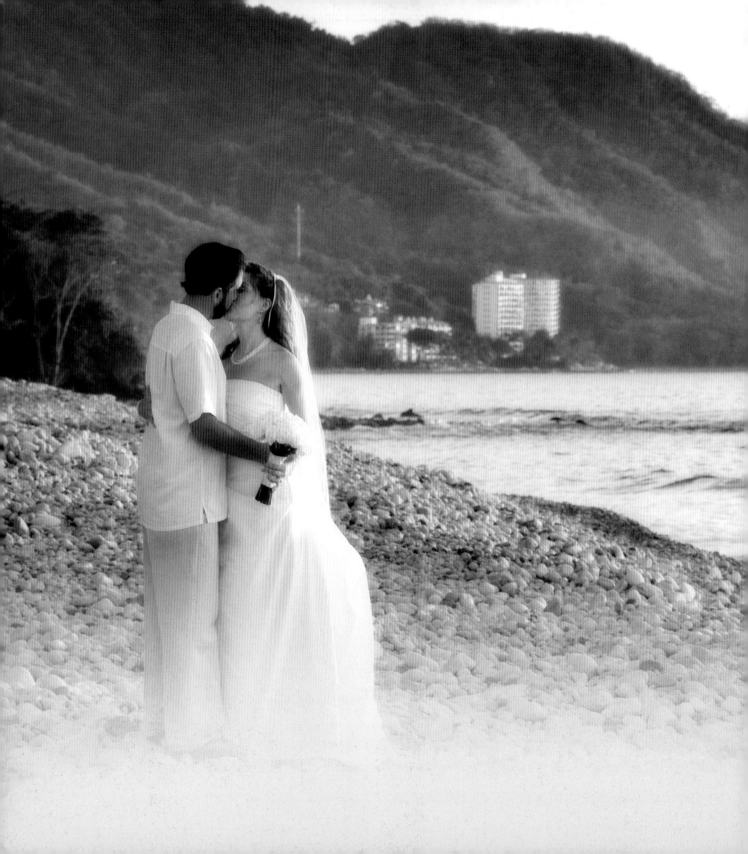

Once you finish processing your images, you will need to output them. Some photographers simply burn a DVD of all of the images and hand them over to the couple to do with as they wish. Others proof using 4x6 in (10.2x15.2 cm) or 5x5 in (12.7x12.7 cm) paper proofs. Some create online web galleries that allow couples to view and order their images online. Others create a slideshow, showing it via projection, posting it to the web, creating a DVD, or making it available as an iPod download. Of course, many photographers still create beautiful, custom albums. Framed prints are still popular, and gallery wraps are increasingly in demand. Whichever method you choose, there is software available to help you along.

Output

\mathscr{P}roofing and Ordering

PRINT PROOFS

If you choose to proof using actual prints, there are two common ways to do so: 4x6 in (10.2x15.2 cm) or 5x7 in (12.7x17.7 cm) bordered prints or image catalogs.

a. Bordered Prints

If we are giving the bride and groom 4x6 in (10.2x15.2 cm) prints, we like to put a border on them to enhance the presentation. We also resize them and sharpen them at the 4x6 in output size. There is a fantastic script available from Mike Dickson (*www.photosforlife.ca*) that runs on CS3 to prepare your images for printing. Using this script you can add a border, add the image number, add your logo and even run actions on the images at various stages in the process. We like to run a sharpening action. There are some really great ones out there, but almost every image that leaves our studio has been sharpened with Kevin Kubota's MagicSharp action, available at *www.kubotaimagetools.com*. After resizing, bordering, and sharpening our images, we upload them to our lab.

Above: It's easy to create your own thumbnail catalogs using Photoshop's Contact Sheet II dialog.

b. Proof Catalogs

There are several labs that will take your images and make a proof catalog (large, bound sheets of thumbnails of all of the couple's images, usually with the image number underneath), but it is easy to prep your own catalog if you are printing it yourself or if you are a control freak like I am! Open Photoshop, select File > Automate > Contact Sheet II. Select the folder where the images are, then tell it the size of the page you want it to create and how many rows and columns you want. On the right, it will show you what your sheet looks like and how many pages you will need to accommodate all the images in the folder you selected. Then click OK and Photoshop will create the sheets for you. You can print and bind these yourself or send them away to be printed and bound by a professional lab or album company.

It is easy to prep your own catalog if you are printing it yourself

WEB PROOFS

If you choose to proof via the web, you also have several options ranging from expensive to reasonably cheap. There are benefits and drawbacks of each, so it is important to explore several to see which is right for you.

a. Hosted Web Gallery

Several online services exist that will take your images and create a web gallery, host it on their website, password-protect it, take orders and even fulfill those orders for you. However, many of these services charge a hefty service fee, upload fee, or take a large commission. They can be useful, however, if you want someone else to shoulder all the work associated with selling your images.

b. Customized Web Gallery

There are two excellent companies that will create a customized web gallery for you that matches your website. You then upload individual galleries and password-protect them. The website will email you every time you receive an order, often automatically processing the payment for you. You then prepare the images and send them to your preferred lab for printing. We use the Skooks Kart service (*www.skookskart.com*) and love it. Another one is Pickpic (*www.pickpic.com*)—both are excellent solutions.

Several online services exist that will take your images and create a web gallery

\mathcal{S}lideshows—Projection, Web, and DVD

Slideshows are another good way to display your images. Often set to music, they create an emotionally charged presentation. There are several ways to show your couple their slideshow—some photographers project it for them in the studio or in their homes. This gives you the opportunity to view their reactions at first hand. There are several programs available that will help you with slideshow creation for projection—one of our favorites is ProSelect (*www.timeexposure.com*).

iMovie HD and then export our slideshows to iDVD to create beautiful slideshows with custom transitions. Here are some other programs that we like: TalaPhoto (*www.talasoft.com*) can also export your slideshow at a size appropriate for DVD. ProShow (once again, not Mac-friendly) creates beautiful slideshows that can be exported to DVD. ShowIt Web (*www.showitfast.com*) now offers ShowIt DVD, to enable your customers to order a copy of their web slideshow on DVD.

View as Slideshow at any time from within Windows Vista's Explorer windows.

Windows Photo Gallery, supplied with some versions of Windows, can burn to DVD.

Another great way to show your slideshow is via the web. You can either show it as a Flash presentation or as a QuickTime Movie—both are effective. There are some great programs that will help you create your web slideshow. The one we use is ShowIt Web (*www.showitfast.com*). This program can help you create a beautiful Flash slideshow. Another great one (although not Mac-friendly at the time of writing) is *ProShow Gold* (www.photodex.com). If you want to create a QuickTime Movie, TalaPhoto (*www.talasoft.com*) will help you output your slideshow at several different sizes, including a web-friendly version.

Finally, you can provide your couple with a DVD of their slideshow that they can watch from the privacy of their own home. We use

There are some great programs that will help you create your web slideshow

Above: TalaPhoto is a tool designed to provide quick and easy effects. It is available for both Mac and Windows computers.

Above: To create a more sophisticated look, you can add your photos to iMovie and then use the "Ken Burns Effect" so that the camera slowly pans in on or away from part of your photo.

Left: If you're using a Mac, iDVD is a useful tool for creating slideshows that can be distributed to and watched by anyone with a DVD player.

Printing Solutions

There are two basic printing solutions available: you can print in-house on a photo printer or you can send your images to a lab to be printed. There are benefits to both. Professional labs can provide you with a cheaper way to present your images and often offer specialty items such as metallic paper, gallery wraps, and image mounting and spraying. Printing on your own printer will allow you more control and different options—for example, we print at home if we want to print on watercolor paper or another type of fine art paper.

Large-format printers are a big investment, but you may save money on lab fees in the long run.

If you want to have your images printed at a professional lab, the web has made it easy to choose a good one. Whereas you used to have to take your film to a local lab or risk sending it away, you can now FTP your files directly to your lab—anywhere in the world. We have used several, but our favorite labs are WHCC (*www.whcc.com*), Mpix (*www.mpix.com*), and The Edge (*www.theedgephoto.com.au*).

SPECIALTY PRODUCTS

There are so many photo products available right now that it is sometimes a difficult task to decide what to offer. We still offer custom, enhanced prints (both framed and unframed). Using Photoshop, we can now design custom collages and storyboards for our couples that can be sent to the lab and printed as one large image.

One of our favorite products is currently the Gallery Wrap. Offered by several companies including Simply Canvas (*www.simplycanvas.com*) and WHCC (*www.whcc.com*), the gallery wrap is an image printed on museum-quality canvas that is stretched over a wooden frame and wrapped around the sides to produce beautiful wall art that does not need to be framed.

We also offer specialty cards. Several companies print custom cards, from postcards to folded notecards to trifold cards—including our lab, WHCC. We offer these cards to our couples as thank-you cards or holiday cards. They have a choice of surface, from a shiny pearl to textured linen. Usually the companies that print these cards offer Photoshop templates to help you design them.

Although we offer them more for our children's portraits, we also offer a line of custom photo bags through Snaptotes (*www.snaptotes.com*). We also have a few couples every year who want something special—magnets or stickers for "Save the Date" announcements, for example. We have even been asked to create custom bookmarks.

There are several types of printers available, ranging from dye sublimation printers to inkjets. Printers are also available in many sizes—we have a printer that will only print 4x6 in (10.2x15.2 cm) prints and one that will print anything up to two feet (61 cm) wide and several feet long. Of the companies that sell printers to make professional-quality prints, my personal favorite is Epson, but Hewlett-Packard and Canon make great printers as well, all with their own distinct advantages (Canon, for example, offer many printers capable of printing onto the label side of CDs or DVDs, which helps make a good impression on clients). Our printers will let us print on almost any type of paper imaginable, controlling the blacks with a few different types of black ink. Color rendition, with the proper calibration and paper profile, is excellent. Just make sure that you create your own or download the appropriate profile for your printer and the paper that you want to use.

Printing on your own printer will allow you more control and different options

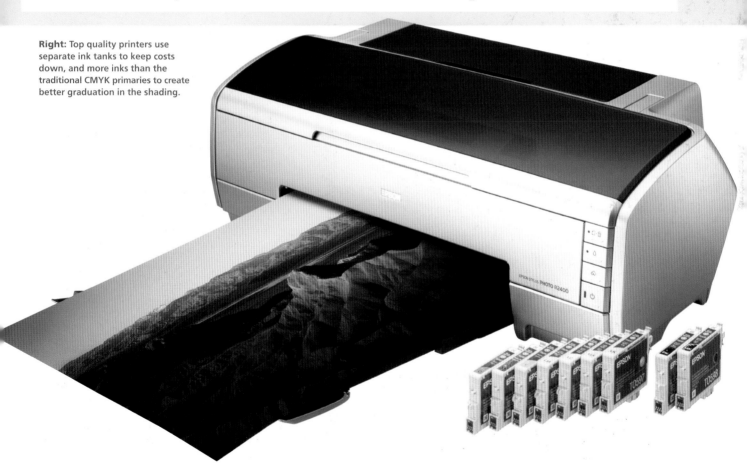

Right: Top quality printers use separate ink tanks to keep costs down, and more inks than the traditional CMYK primaries to create better graduation in the shading.

Our most popular specialty product is our line of custom-designed albums. We offer two types of albums to our clients: traditional matted albums and contemporary, magazine-like printed albums. The great thing about albums today is that we can design everything in our album design programs—even our matted albums are custom designs with individually cut mats.

There are some great album suppliers out there—we personally use Albums Australia (*www.albumsaustralia.com.au*) and John Garner Bookcrafts (*www.bookcrafts.net*) for our high-end books and Vision Art Book (*www.visionartbook.com*) for our entry-level album. I have also seen fabulous books from Leather Craftsmen (*www.leathercraftsmen.com*), Jorgensen Albums (*www.jorgensenalbums.com*), Queensberry (*www.queensbery.com*) and Forbeyon (*www.forbeyon.com*).

For us, it is important that our album companies provide comprehensive, easy-to-use album design software, especially for matted albums. We are comfortable using Photoshop, Yervant's Page Gallery (*www.yervant.com.au*), or You Select It (*www.youselectit.com*) to create our magazine albums, but I want the ability to create custom mats in a variety of sizes and combinations without complication. The great thing about companies like Albums

Right: Every couple wants their album to be unique. Try to use suppliers that will deliver albums to your custom specifications.

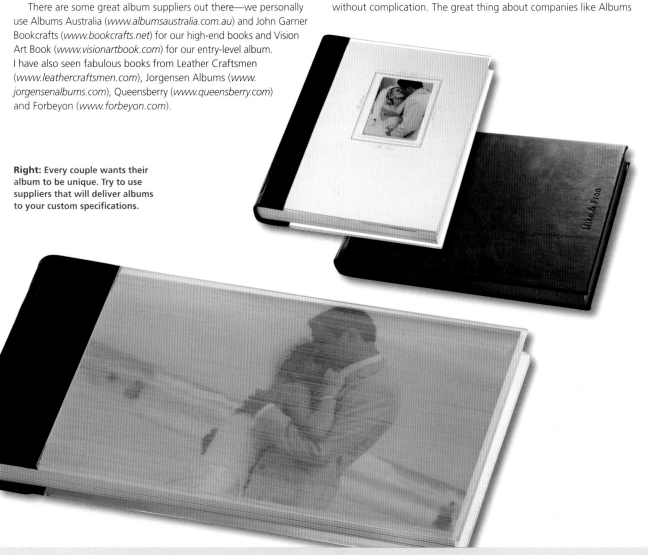

Above Left: Some suppliers provide software that allows you to choose from a selection of images and add them to a pre-designed page template.

Above Right: You don't need to stick rigidly to the templates, as there are sophisticated editing tools available to help you tweak the designs.

It is important to be able to create albums in custom sizes

Australia, Jorgensen, and Queensberry is that they provide you with the software that you need to create beautiful albums. TDA, the design software available from Albums Australia, allows me to design albums and see the changes in real time. I can create mats in thousands of configurations, but they also have several great templates ready for use. TDA will also take my images and prep them for the lab, cropping them to the exact specifications that I chose in my album design, while I take a break from the computer!

It is also important to me to be able to create albums in custom sizes. I also like to create horizontal albums because of the way I shoot. The great thing about Albums Australia and Bookcrafts is that I can design my magazine albums in any size or format and they will make it for me. It allows me to create something unique for my couples, which they appreciate, and which makes my albums memorable.

Keyboard shortcuts

LAYER	Mac	PC
New Layer	⌘+⇧+N	Ctrl+Shift+N
Layer via Copy	⌘+J	Cmd+J
Layer via Cut	⇧+⌘+J	Shift+Cmd+J

SELECT	Mac	PC
All	⌘+A	Ctrl+A
Deselect	⌘+D	Ctrl+D
Reselect	⇧+⌘+D	Ctrl+Shift+D
Inverse	⇧+⌘+I	Ctrl+Shift+I
All Layers	⌥+⌘+A	Ctrl+Alt+A
Refine Edge...	⌥+⌘+R	Ctrl+Alt+R
Feather...	⌥+⌘+D	Ctrl+Alt+D

ZOOM	Mac	PC
Zoom In	⌘+⊕	Ctrl+⊕
Zoom Out	⌘+⊖	Ctrl+⊖
Fit on Screen	⌘+0	Ctrl+0
Actual Pixels	⌥+⌘+0	Alt+Ctrl+0

WINDOW	Mac	PC
Actions	⌥+F9	Alt+F9
Brushes	F5	F5
Color	F6	F6
Info	F8	F8
Layers	F7	F7

TOOLS	Mac or PC
Move Tool	V
Rectangular Marquee Tool	M
Elliptical Marquee Tool	M
Lasso Tool	L
Polygonal Lasso Tool	L
Magnetic Lasso Tool	L
Quick Selection Tool	W
Magic Wand Tool	W
Crop Tool	C
Slice Tool	K
Slice Select Tool	K
Spot Healing Brush Tool	J
Healing Brush Tool	J
Patch Tool	J
Red Eye Tool	J
Brush Tool	B
Pencil Tool	B
Color Replacement Tool	B
Clone Stamp Tool	S
Pattern Stamp Tool	S
History Brush Tool	Y
Art History Brush Tool	Y
Eraser Tool	E
Background Eraser Tool	E
Magic Eraser Tool	E
Gradient Tool	G
Paint Bucket Tool	G
Blur Tool	R
Sharpen Tool	R
Smudge Tool	R
Dodge Tool	O
Burn Tool	O
Sponge Tool	O
Pen Tool	P
Freeform Pen Tool	P
Type Tools	T
Path Selection Tool	A
Direct Selection Tool	A
Shape Tools	U
Notes Tool	N
Audio Annotation Tool	N
Eyedropper Tool	I
Color Sampler Tool	I
Ruler Tool	I
Hand Tool	H
Zoom Tool	Z
Default Foreground/Background Colors	D
Switch Foreground/Background Colors	X
Toggle Standard/Quick Mask Modes	Q
Toggle Screen Modes	F
Toggle Preserve Transparency	/
Decrease Brush Size	[
Increase Brush Size]
Decrease Brush Hardness	{
Increase Brush Hardness	}
Previous Brush	,
Next Brush	.
First Brush	<
Last Brush	>

Index

*A*cknowledgments

First and foremost, I would like to thank my family for their support. To Eric, Cody, and Jackson—thank you for all of the love and encouragement through the destination weddings and the late nights of editing and writing. To my mother, Peggy—thank you for the encouragement and the stories that kept me laughing. To my mother-in-law, Wini—thank you for all of the childcare while I was busy shooting and writing.

I would also like to thank my good friends and colleagues—you all inspire me to keep pushing myself to create interesting images. I appreciate all the feedback, the brainstorming, and the support more than you could ever imagine. To Nadra Edgerley and Sharyn Peavey—thank you for the monthly breakfasts and for the reality checks. To Alicia William and Jay Philbrick—thanks for setting up the interesting shoots and the coffee meetings that last all day!

To Adam Juniper and the Ilex Press—thank you for entrusting me with this fun project. If there is one thing I love to do more than photographing couples, it is to talk about photographing couples! Adam, thank you for all of your tireless efforts and great suggestions—you have been a wonderful editor and I have really enjoyed working with you.

Finally, a huge thank you to my couples for trusting me enough to let me approach their weddings with a different and creative eye. Especially my brides, who never worried about getting their dresses dirty! Well, almost never....

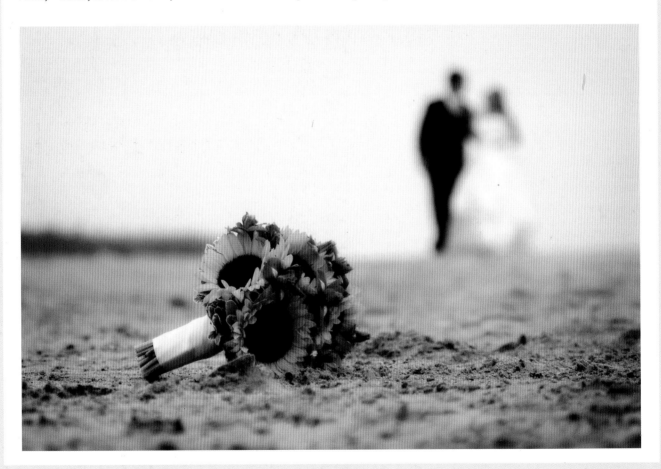